PROPOSITIONS FOR N
TENTATIVE AND URGE

Editors: Maria Hlavajova and
Managing Editors: Irene Cala
Associate Editor: Colin Becke
Copyediting: Colin Beckett
Proofreading: Guy Tindale and Eleanor Weber
Design: Sean van den Steenhoven for Leftloft

Cover Image: Forensic Architecture, *Investigation into the Murder of Pavlos Fyssas*, 2018, video still, detail

Published by BAK, basis voor actuele kunst, Utrecht
and the MIT Press, Cambridge, MA and London, England

This book was set in GT America and Minion Pro and was printed and bound in Belgium.

Distributed by:
The MIT Press
Massachusetts Institute of Technology
Cambridge, MA 02142

Library of Congress Control Number: 2019934557
ISBN: 978-0-262-53789-6

Propositions for Non-Fascist Living: Tentative and Urgent

Edited by Maria Hlavajova
and Wietske Maas

BAK, basis voor actuele kunst, Utrecht
The MIT Press, Cambridge, MA and London, England

Table of Contents

Editors' Note. Propositions for Non-Fascist Living: Tentative and Urgent

Maria Hlavajova

This publication is a tentative probe into propositions for non-fascist living. An urgent task, it appears, given the dramatic resurfacing of fascisms all around the globe. It is not only historical fascism, misguidedly thought to have been buried for good in the mid-twentieth century, but fascisms in their multiple contemporary mutations, seizing upon life across the multiplicity of its forms and thus upon the very prospect of living. Fascisms aimed at destroying the material, intellectual, and emotional foundations of life—human and non-human, organic and non-organic—across its social, political, and ecological planes. How, then, to envision the possibilities of living not merely against, but in spite of this?

Some believe we do not yet have a satisfactory name for the "new" reactionary forces that amalgamate ultra-nationalism and racism with an endless list of contemporary ills. Think about the multiple, catastrophic iterations of such forces at present. In no particular order and by no means complete, they go under designations such as authoritarian nativism, economic nationalism, white supremacism, far-right-wing militancy, alt-right statecraft, dictatorial posturing, corporate statism, xenophobic rage, destructive environmental governance, patriarchal domination, technological and digital colonialism, omnipresent surveillance, data extractivism, romanticized violence, and criminalized migration, as well as the multiple micro-oppressions that traverse the interstices among these. They are aimed against the masses, even if clad in the masterful pretense that is the "will of the people." There, disguised in rhetoric against elites, hides the discipline and control and oppression of the poor, people of color, refugees and immigrants, minority religious communities, other others (the racialized, classed, gendered, sexualized others: all those dissenting from the dominant notion of Man), and the precarious classes in general. From the

heights of coercive power, these forces then indulge in trickster games with the "malleability" of truth about the politico-economic and ecological agendas they pursue, all the while systematically destroying institutions buttressing facts, education, and justice, and shifting back and forth between post-truth and post-shame. Expertly, they then mobilize collective passions around this new "normal," reliant as it is on the myth that one could return to, or better yet, restore, the putatively paradisiac, heroic past.

Yet, despite the overwhelming hesitation to pronounce it (as if avoiding *the* word could prevent things from happening), and although far from "satisfactory" (how could it be?!), there *is* one name through which to fathom these forces. That name is fascism.

To address fascism as such in the present is no small matter. Indeed, the dominant narrative prefers to see fascism as definitive of the past. Even if, so goes the argument, the conditions that historically gave rise to fascism in Europe in the early twentieth century bear significant political, socioeconomic, psychological, and cultural resemblance to those of today's predicament, they are not the same. Doubtless they can't be. But if nothing else, one feature of this so-called historical fascism should sound the alarm. Namely, its anaesthetic function that prevents fascism from being recognized as such in its own time. Historical fascism, too, though hiding in plain sight, went largely undetected in the time of its political advance. Could it be that "when we think about contemporary fascism as analogous to historical fascism, we should focus on the conditions of its subjective misrecognition?"[1] And that "it is not a question of what in our social reality resembles fascism from the past, but rather what deceives us into failing to recognize its coming from the future?"[2]

To be sure, the historical analogy is both imprecise and limiting. Not least because of its Eurocentric worldview, which fails to recognize its own outstretched shadows and extended continuities; between patriarchy, colonialism, imperialism, and fascism, for example, as they appertain throughout the infrastructures of life past, present, and future. Understanding that fascisms (and let's identify fascisms in their plural, multiform constellations) arrive from uncertain futures means, at the same time, that fascisms—much like these uncertain futures—have been a permanent feature of politics across a multiplicity of geo-politico-historical contexts, nurtured by the use of us-against-them ideologies, incrementally or aggressively, openly or clandestinely, whenever and wherever pathways to oppressive power have been paved.

Against such a diagnosis, this publication urges us to recognize fascisms as what, to a large extent, shapes the conditions of the present. To see fascisms in their expanded sense—historically, geographically, and substan-tively—as a cluttered composite of multiple large-scale, state-corporate, dictatorial, militaristic, and destructive conducts *as much as* of the micro-authoritarian impulses colonizing the everyday through patriarchy, misogyny, bigotry, xenophobia, racism, and many other cultural codes at odds with the values of social and ecological justice. And yet, the historical or contemporary variations of fascism—their cartographies, definitions, representations, or simply their critiques—are *decidedly not* what this book is about. Instead, this book is an uncompromising *rejection* of fascism. Stronger yet, this very rejection of fascism is a *driving force* behind its coming to life, conjoint with an intense yearning for *being together otherwise.*

The ethical and political foundations of the project *Propositions for Non-Fascist Living*[3] lie in this tension

between the oppositional and the generative. Between the vital yet dissonant urgency to resist the fascist predicament of the present on the one hand, and on the other, to think, imagine, and actualize the alternatives. Concurrently activating resistance and alternative imaginings, the project seeks to engage relationalities that refuse dichotomies and mere oppositional thinking. It does so to disrupt the modern operation of critique as little more than an assessment and diagnosis of conditions, and to propel that critique into a propositional modality. Simultaneously then, the project engages the creative force of the imagination in art and daily activist practices with the robust task of envisioning and materializing the world *otherwise.* How can such *critique-as-proposition* help to repurpose one's dialectical positioning into grounds from which to imagine, create, and inhabit alternatives? How to create *propositions*, not merely as conceptual fictions, but also as projects of fact, both against and in spite of the fascist predicament of the present, and so practice a *non-fascist living*?

In search of the means to generate knowledge about, develop proposals for, and activate tactics of the "art of living counter to all forms of fascism, whether already present or impending,"**4** the book borrows the term "non-fascist life" from philosopher Michel Foucault. It is a form of life that, following Foucault, counters "not only historical fascism, the fascism of Hitler and Mussolini—which was able to mobilize and use the desire of the masses so effectively—but also the fascism in us all, in our heads and in our everyday behavior, the fascism that causes us to love power, to desire the very thing that dominates and exploits us."**5** Devising a set of principles to guide everyday non-fascist life, Foucault cautions readers to "[w]ithdraw allegiance from the old categories of the Negative (law, limit, castration, lack, lacuna), which Western thought

has so long held sacred as a form of power and an access to reality. Prefer what is positive and multiple," Foucault continues, "difference over uniformity, flows over unities, mobile arrangements over systems. Believe that what is productive is not sedentary but nomadic."[6]

Following this line of thought in her contribution to this book, "Non-Fascist Ethics: Learning to Live and Die as Affirmation," philosopher Rosi Braidotti thinks through ways of countering the cult of negativity—"a defining trait of fascism as a social and psychic reality"—through affirmative ethics. Rather than a simplistic denial of the paralyzing force of negativity that is abuse of power, the materialist, affirmative ethical stance deals with negativity in a generative way, seeking to transform negative occurrences into productive relations. Unlike dialectics, which fuels "the energy for political resistance through opposition, negation, and the antagonistic drive for recognition," this mode of opposition engages both the reactive resistance and active resources of desire and imagination in counter-actualizing alternatives to the present.

Such a counter-actualization of alternatives must aim at no less than ending the world "as we *know* it," according to artist and theorist Denise Ferreira da Silva as she articulates it in "Notes on the Underside of Visibility," a conversation with Jota Mombaça and Thiago de Paula Souza. To end this way of knowing the world—and thus to end *this* world—means ridding it of the edifices sustaining the "colonial, racial, environmental, and cis-heteropatriarchal total violence" of western modernity. These conceptions include critique and representation, as well as the very idea of "liberty" that is central not only to liberal thought, but also to its "'opposite,' the modern conservative alternatives such as Nazism, fascism, and all the varieties of white nationalism." To practice toward this "knowing the

world differently," Ferreira da Silva develops the conceptual device of "blacklight," which—unlike the white light that "only shows that which is recognizable, that whose contours are already named"—helps uncover meanings relegated to the "underside of visibility." This allows for a version of critique that is not the banal exposition and rational assessment of conditions at hand, but rather a deep engagement with what lies at the limits of justice. This measure of disruption "will require an image of *justice* that is not framed by the principles of liberty and equality," so that it can "stop the destruction of the world by global capital and its agents."

Forensic Architecture puts under scrutiny the agents of such ruthless destruction, namely nation-states and corporations (or better yet: corporation-states). An agency composed of architects, filmmakers, artists, coders, and journalists that operates across multidimensional political, economic, judicial, economic, and cultural forums, Forensic Architecture uses innovative technological and architectural methods to investigate alleged state and corporate violence. "An Impromptu Glossary: Open Verification" consists of a number of annotated terms that renegotiate the language and practice of mainstream politics today. If "counter forensics," as Forensic Architecture refers to their practice, is to seek new modes of verification and open, poly-perspectival, multi-talented, and collective truth production in the era of post-truth, it also serves to build alliances against the "dark epistemology" of the present. Dark epistemology is the place from within which the authoritarian present emerges ever anew as it upsets the distinctions between fact and fiction and between true and false, thus marking the origins of totalitarianism as we have learned of them from political philosopher Hannah Arendt.[7] In resisting dark epistemology, Forensic Architecture engages with

a "vital and risky form of truth production, based on establishing an expanded assemblage of practices—the unlikely common—that incorporate aesthetic and scientific sensibilities and include both new and traditional institutions." This dismisses the separation of aesthetics from knowledge production, instead aligning them through multiple transversal connections into a space not just of "narration, performance, and staging" but also of pre-enacting, pre-instituting even, another sociality.

At a similar juncture of art, social movements, and the infrastructure of law, unfolds the visual essay "Scarecrows" by artist Jumana Manna. Here, Manna images daily acts of defiance by Palestinians foraging wild plants for food and medicine; something their survival has depended on for centuries. These humble resistances take place in the face of the legal prohibitions imposed by the State of Israel. The thinly veiled imperialist and racist laws, disguised as preservation decrees protecting plants and other species, are aimed, de facto, against the very possibility of people sustaining their lives on their own lands. "Lands that, in many cases," Manna stresses, "have been expropriated by the Israeli state and are administered as Israeli settlements, nature reserves, military training areas, and other forms of 'state land.'" The state here, indeed, continues usurping the power to decide "what is made extinct and what gets to live on; about who gets to decide the fate of these foraging traditions and the options that remain for those who don't."

Working with and through the notion of propositions for non-fascist living means inquiring into the conceptualization and actualization of forms of collectivity that can foster resistance to the fascist present by actually practicing emancipatory politics. In this respect, theorists Stefano Harney and Fred Moten caution against the

ethics of individuation that undergird the idea of politics and the commons: "The idea of the commons leads to the presumption of interpersonal relations, and therefore of the person as an independent, strategic agent... Such persons make not just commons, but states and nations." To refuse this "collection of individuals-in-relation"—of individuals as "the very free subjects who can do nothing but privatize, externalize, and brutalize"—as wholly inadequate in the face of challenges present and future, Harney and Moten think through the *undercommons.* The undercommons as, indeed, "the refusal of the interpersonal—and, by extension, the international—upon which politics is built." Adhering to the Black radical tradition, the undercommons departs from the path Foucault cuts, "because that path, which is the animate body's path, has always been denied to the flesh, and therefore most especially to black people, who are for historical reasons disentrusted with the keeping of what becomes what it always was: blackness, that anoriginal communism." Black imagination in the face of fascism is then an example of living at odds with modern morality: the morality of "the victory of reason over its rivals"; of the human "who lives with impunity on the earth and is sorry about it"; "of our earth and its reduction to the world"; etc.—thus living "history and place without succumbing fully to emplotment," that is, without succumbing to time and space of capitalist production, and living instead "an attachment, a sharedness, a diffunity, a partedness."

"The Thread and the Gap" by artist Patricia Kaersenhout and theorist Lukáš Likavčan expands on these propositions by means of a feminist *poethics* as it performatively disrupts modern aesthetico-political strategies, and ventures into the poetico-ethical realm of relations. The flow of images in this visual essay issues from a performance in which Kaersenhout and Likavčan[8] patiently and

enduringly weaved yarn stretched on a handmade loom. The serene gestures of their hands and whole bodies moved to the hypnotic sound of the poem "Ossuary I" by Dionne Brand: itself a powerful contemplation of the crises of our time; itself in continuous movement; itself drenched in the belief that another sociality is possible. Inviting—by touch—the members of the audience to help in the process, guiding them silently on and off the stage, learning to weave from one another patiently and silently, slowly and laboriously, it became obvious that what was woven was not cloth but communality. An *assembly* convened performatively; not of individuals but of emotions, ideas, knowledges, and, crucially, another relationality.

When thinking through the notion of a political assembly or "assemblism,"[9] it is "imperative to think who gets to be included in the 'us,'" as postcolonial scholar Shela Sheikh cautions in her contribution "More-than-Human Cosmopolitics." Building upon posthumanist, postcolonial, and critical race scholarship, Sheikh envisions an expanded, multi-species sociality of "humans and non-humans, and the political agencies that might arise through such relations." Could "artistic practices," Sheikh asks, "help us to imagine such forms of sociality and composition and to build a non-fascist, more-than-human cosmopolitical world, rather than simply representing it?" Not just *any* artistic practice, it must be added, since the art world, specifically that of the west, despite its self-aggrandizing claims to political change, mostly recycles the blatantly modern-colonial conventions of critique and representation, packaged neatly for consumption by the art market. But, rather, *those* practices of art that speculatively and propositionally "contest increasingly fascistic modes of governance," pre-enacting, as it were, new infrastructures—new legal spaces included—for the collectivities where non-fascist life could be not

just envisioned but lived "outside of western binaries of nature/culture, active/passive, and so forth, opening up space for the traditionally marginalized 'non-experts' to make both objections and proposals."

As in the entwinement with what used to be called nature, the expanded collectivities and interconnectedness in the posthuman convergence must be equally insistently examined through the digital-technological perspective. In his contribution "Non-Fascist AI," Dan McQuillan, a scholar of computing, takes on artificial intelligence through a succession of questions, from "Does AI have a politics?" and "Is AI fascist? to "How can we resist fascist AI?," in order to speculate about potential ways of achieving non-fascist AI. To be sure, following McQuillan, it is possible to discern "authoritarian tendencies associated with AI," as it functions as an overlay to the authoritarian conditioning that defines today's society through patriarchy, racism, etc., and bearing in mind the uses to which AI is put in the current political predicament. In a culture prioritizing "scientific authority," AI delivers on the demands for (seemingly) objective, ideologically neutral, depoliticized calculations in social contexts that are, rather, in need of a subjective discourse in the form of dialogue and human judgement. In such blatant reductions of social issues, "AI not only undermines due process, but produces thoughtlessness," writes McQuillan, "in the sense that political philosopher Hannah Arendt meant when interpreting the actions of Nazi war criminal Adolf Eichmann: inability to critique instructions, lack of reflection on consequences, commitment to the belief that correct ordering is being carried out. These are forms of everyday fascist thinking, even when not undertaken on behalf of an explicitly far-right regime." If there are multiple correlations between the workings of AI and fascist governmentality, then in order to envision non-fascist AI,

McQuillan turns to feminist and decolonial technology studies, and in particular the feminist politics of care and relationality, in order to seek empowerment from within the position of disadvantage. McQuillan proposes that "a non-fascist AI must involve some kind of people's council, to put the perspective of marginalized groups at the core of AI practice, and to transform machine learning into a form of critical pedagogy." From here, a non-fascist AI must commit to autonomy; to an uncompromising "refusal to be dominated, but also of refusing to dominate anyone else, by rejecting any participation in oppressive patterns of interaction." Based on "solidarity, mutual aid, and collective care," such AI is not one of autonomous machines, but "a technics that is part of a movement for radical social autonomy."

This radical social autonomy is to be understood as a version of autonomy uncoupled from its neoliberal expressions; much in the sense of the notion of autonomy that art historian Sven Lütticken calls for in his text "Abdicating Sovereignty." Indeed, Lütticken pleas for liberation from neoliberal notions of autonomy, along with liberation from neofascist versions of sovereignty. For both autonomy and sovereignty, as they are known under advanced capitalism today, co-exist with the (neo-)fascist condition, shaping jointly the notion of life as incessant toil and mere survival. To move through such a conundrum, "[t]he sovereign individual must abdicate, just as the autonomous subject must take his hat." Lütticken turns to a radical feminist understanding of autonomy, adamant that it need be understood "not in terms of a delusional autarky, but as the ability to choose one's dependencies." And sovereignty? In the face of the disastrous neoliberal present of double sovereignty (wherein "the one per cent get one kind, the rest get national sovereignty—and, more particularly, the promise of a kind of national sovereignty

in which many are classified as non-humans, and whose classification wars can put even poor whites in a position of mastery"), Lütticken points at the revival of interest in affect, and in love in particular. The "sovereignty of love," a counterweight to the sovereignty of the state as it were, might offer a space from which to develop a partial and problematic yet also a "practico-speculative response" to present conditions. "We need to dis- and reassemble," writes Lütticken in conclusion, stressing an urgency to continue seeking alternative modes of being together, against and in spite of ever worsening conditions.

But then: in this "painstakingly slow work on (inter-/trans-) subjectivity"—in this "dis- and reassembling" as Lütticken has it—how to reconcile the new modes of living with the worlds that are dying, or the worlds that "have ended before, destroyed by racism, slavery, patriarchy, and capitalism," as Braidotti inquires? And how to live with "a metric of terror, despair, depravity, or loss" whenever the dead are enumerated in calculations of destruction, as artist and scholar Mick Wilson asks? And, finally, how to "live the coming death?"

The latter question is eponymous with Wilson's contribution to this publication, enquiring into the western-modern techniques of death accountancy as a disinterested record of the casualties of inequality and of the systemic horrors that continue to constitute the world at present. These accounts attest that "some humans have arrogated to themselves the right and the capacity to manage all life on the planet," Wilson notes, forewarning the "moral economy of violence to come." Predicated on the vastness of the coming death—continuing the genocidal, ecocidal, and politicidal project of colonial modernity at the juncture of the sixth extinction and necropolitical governance—there stands, looming on the horizon, the threat "to the life of

life itself." To live this coming death, assembling a political community *with* the dead becomes imperative. This requires one "to collectively re-imagine death as something that cannot be reduced simply to non-existence," so that, instead, "the dead are counted as *beings* among the living—not as revenants or ghosts, but as beings in disjunctive co-belonging with the living." That way "it may just be possible for the dead to *count*, and not simply be counted, against the moral economy of violence that is premised upon the coming death."

The coming death, as I understand it, is potentially the death of not "just" mass extinction, but extermination; not "just" collective death, but collective murder. This is a chilling reminder that fascism is no discursive struggle but a bellicose turf war, in which matters of living and life switch seamlessly into matters of dying and death. As I write, the Turkish military is forcing its way into northeastern Syria, targeting the Kurdish communities and their Assyrian and Arab allies with heavy artillery, enforced displacement, and the threat of ethnic cleansing. Invited in by a phone call from one authoritarian leader to another, the heavy sounds of shelling multiply. Under attack and facing destruction are not only people, communities, and lands, but also one of the most powerful proposals, certainly of this current time, for non-fascist living: the lived political experiment of *stateless democracy*.[10] Based on six key principles—the principle of secular politics, the principle of multi-ethnic governance of public institutions, the principle of gender equality, the principle of communalist self-government, the principle of confederalism, and the principle of social ecology—the model of stateless democracy is a fundamental critique of the unsustainable fantasies of the nation-state, itself a patriarchal construct in service of global capitalist doctrine and its co-present fascisms. Built against and in spite of such reality, the

remarkable practice of feminist social transformation in Rojava over the last seven-plus years, with its building of a society based on bottom-up, direct democracy, the liberation of women, and ecological principles, is the real threat to the fascisms of today. For it holds a promise of—and a concrete practice of living—another society and another earth; a promise of *being together otherwise*. As Dilar Dirik, an activist of the Kurdish Women's Movement has stated,

> The question of how to live non-fascist lives is no longer a luxury. It is no longer an option that we can consider. It is a matter of life or death. In a life, in a system, in a world where every area of life, where nature, where communities, where societies, where ancient forms of living, where the last remaining forms of solidarity are systematically annihilated, we no longer have the luxury to think about how we can live non-fascist lives in an individual manner. No, we have transcended that situation a long time ago. We need to think about ways in which we can collectively build up non-fascist systems, not only non-fascist individualistic forms of being, of existence. We can no longer think about ourselves: How can I live a non-fascist life? How can I be a leftist? How can I be a radical? We cannot be radical if we are not rooted inside communities. We cannot be radical, revolutionary, if we only seek solutions for ourselves individually. As the experience of the Kurdish freedom movement has shown, and espe-cially as the women of Kurdistan have demonstrated, not only in their fight against the so-called "Islamic State," but against patriarchal fascism, against the fascism of nation states, against the fascism of capitalism, is that freedom is something that has to be built in the here and now.[11]

This publication is dedicated to Kurdish Women's Movement with whom it shares this very goal.

—

Propositions for Non-Fascist Living: Tentative and Urgent is the inaugural publication in a new series from BAK, basis voor actuele kunst, Utrecht. Titled BASICS, the series embarks on an exploration of some of the most urgent concerns of our time by engaging with theoretically informed and politically driven artistic practice. If BAK is conceived as a *basis*—a base where art and theory meet social action—from which to act *propositionally*, through the social, political, environmental, and technological conditions that shape the present, in order to develop and actualize proposals for *being together otherwise*—then BASICS is its publishing equivalent. BASICS prompts readers to dwell on the fundamental questions that shape the present and attempts to offer ways to narrate the contemporary predicament, as well as ways to resist it. In response to the current global and planetary emergencies, BASICS seeks to develop afresh the building blocks of lexicons, tactics, scenarios, and relations by means of collective aesthetic-political experimentation into actualizations of alternative futures.

I would like to take this opportunity to thank all the contributors to this publication for their profound reflections as to how one could live in the face of today's fascist predicament. I also thank the contributors to the publication's namesake, the research project undertaken at BAK, *Propositions for Non-Fascist Living* (2017–ongoing). This is a long-term itinerary for generating knowledge about, developing proposals for, and activating tactics of *non-fascist living*: that is to say, practicing life, and thus modeling a world as it were, determinedly voided of fascisms. I owe my heartfelt appreciation to the co-editor of

this publication, Wietske Maas, for her immense dedication to this project, as well as to the editorial team without whom the book could not come to life. Equally, I thank the book's co-publisher The MIT Press and, in particular, Victoria Hindley. Last but not least, my gratitude goes to my colleagues at BAK for their unrelenting commitment to carving the path through the field of art to where propositions for non-fascist living, and thus for *being together otherwise*, are not only urgent but possible.

1: Boris Buden, "With the Blow of a Paintbrush: Contemporary Fascism and the Limits of Historical Analogy," *e-flux journal,* no. 76 (October 2016), https://www.e-flux.com/journal/76/73534/with-the-blow-of-a-paintbrush-contemporary-fascism-and-the-limits-of-historical-analogy/.

2: Ibid.

3: *Propositions for Non-Fascist Living* is the eponymous long-term research trajectory at BAK, ongoing since 2017.

4: Michel Foucault, preface to *Anti-Oedipus: Capitalism and Schizophrenia,* by Gilles Deleuze and Félix Guattari (London: Continuum, [1984] 2004), p. xiii. With thanks to Rosi Braidotti for bringing this notion to our attention during research at BAK.

5: Ibid.

6: Foucault, p. xiii.

7: Hannah Arendt, *The Origins of Totalitarianism* (New York: Harcourt, Brace and Co., 1951).

8: *The Thread and the Gap,* a performance by Patricia Kaersenhout and Lukáš Likavčan, took place on 22 June 2019 at BAK, basis voor actuele kunst, Utrecht in the context of *Propositions #8: I Wanna Be Adored (the Non-Fascist remix).*

9: The term "assemblism" has been introduced by artist Jonas Staal at *Propositions #2: Assemblism,* 25 November 2017; it is discussed in this book by Shela Sheikh.

10: *New World Academy Reader #5: Stateless Democracy,* Renée In der Maur and Jonas Staal in dialogue with Dilar Dirik, eds. (Utrecht: BAK, basis voor actuele kunst, 2015). The fifth sequence of New World Academy, an alternative educational platform established by artist Jonas Staal and BAK, basis voor actuele kunst, Utrecht, took place in 2015 and was organized with the Kurdish Women's Movement.

11: An excerpt from the video statement by Dilar Dirik in the context of *Propositions #1: What We Mean,* BAK, basis voor actuele kunst, Utrecht, 7 October 2017, https://m.youtube.com/watch?v=YVZS_utEUrM.

In the following texts please note that, wherever authors have specified their choices of vocabulary and style, this has been retained by the editors.

Non-Fascist Ethics: Learning to Live and Die as Affirmation

Rosi Braidotti

In this essay I will outline an ethics of affirmation and extend it in two directions: a non-fascist ethics that opposes the negativity of our times and an affirmative approach to death and dying.

Affirmative ethics is the opposite of the hypocritical optimism promoted by advanced capitalism for the sake of consumerism. A shallow veneer of enforced cheerfulness barely conceals the social, environmental, and psychic devastation induced by a financial economy based on collective indebtedness. A mix of euphoria and anxiety defines our era, caught between the fourth industrial revolution[1] and the sixth extinction.[2] Neoliberalism adds to this already contradictory picture the moralizing tendency to hold individuals responsible for the ravages of the system, for instance by privatizing issues of health, education, prosperity, and mental wellness. Masses of quantified "dividuals" (i.e., individuals formatted by the schizoid flows of advanced capitalism) self-monitor the management of their bodily, psychic, and affective "capital," without need for further external control. The extent to which intimate and potentially subversive spaces are embedded into capital flows is best exemplified by the billions of Facebook pages that multiply and enfold personal data into global power formations.

By contrast, affirmative ethics is a materialist stance that speaks truth to power and avoids optimistic psychological simplifications by acknowledging the injustices of contemporary socio-economic structures. What this ethical stance affirms, however, is the necessity, as well as the desirability, to transform negative instances into productive relations. Following the honorable tradition of extracting knowledge from pain in order to transform its negative effects, affirmative ethics requires an adequate understanding of the critical conditions one is attempting

to resist. Opposition cuts in two directions: it means both "I reject this" and "I desire otherwise." Both motions mobilize reactive resistance and active—albeit virtual— resources, including our desires and imagination. This is not the denial of negativity, but a generative way of dealing with it.

Affirmative ethics builds on radical relationality. The subject's ethical core is not defined by their moral intentionality as much as by the effects of power, both repressive (*potestas*) and positive (*potentia*), that their actions are likely to exert in the world. The entrapping and the empowering modalities of power are always social, but they are neither dialectically linked nor mutually exclusive. They rather coexist as intertwined facets of the same process of subject-formation.[3] This transversal subject- assemblage does not precede the project that actualizes it, and is neither born of nor exhausted by the performative gesture as a speech act. It is rather a materially grounded praxis that supports affirmative modes of becoming subjects.

Whereas morality is the implementation of socially agreed protocols, ethics is about relations and forces, that is to say, capabilities and powers, as Nietzsche teaches us. These forces are ethically coded as either affirmative and active or negative and reactive. The affirmative is the generative actualization of the virtual, i.e., the expression of *potentia*. The negative is the reactionary administration of institutional *potestas*, represented by the priest, the judge, the fanatic, the conformist, etc.

This ethical scheme rests on a positive notion of desire as Spinozist plenitude (*potentia*), rather than Hegelian lack, which is one of the strengths of vital, materialist philosophy.[4] Spinoza famously defined the core or

essence of the subject as the ontological positivity of the desire to persevere in one's existence (*conatus*). The human being's in-built tendency is toward joy and self-expression, not toward implosion. What constitutes ethical subjectivity is the desire to express one's capacities or powers, the freedom to find out what a body can do, as an embedded, embrained, affective, and relational entity.[5]

Affirmative ethics aims at increasing the individual and collective relational capacity in a productive and mutually-enforcing manner. This practice requires a community—a "we"—that actualizes this ethical propensity for ontological empowerment. Negativity, on the other hand, reduces our ontological relationality and diminishes our capacity to express high levels of productive interdependence with others. It negates *potentia* as our relational ethical essence.

Moreover, the cult of negativity is a defining trait of fascism, as a social and psychic reality. As an infectious infatuation with despotic power, fascism feeds and capitalizes on the hateful rejection of the "others," that is to say those sexualized, racialized, naturalized, or other-wise distinguished from the dominant vision of Man. It thus enacts the closure of the ethical horizon. In contrast, affirmative ethics opposes fascist polarizations. It equates ethical evil with the paralyzing force of negativity, as an abuse of power (*potestas*) that betrays the generative force of *potentia*. I will return to non-fascism below.

The joyful affirmation of freedom, the desire to endure and persevere in one's existence, is not the exclusive preroga-tive of humans, but is shared by all embedded and embod-ied entities.[6] This planetary interconnectedness means that we cannot restrict the ethical life to *bios* alone; we must develop *zoe-*/geo-/techno-centered perspectives.[7]

In other words, vital materialism stresses affective intimacy with the non-human world and also with the technological apparatus. This engagement is not a source of acquiescence or passivity, but exactly the opposite: it allows us to take in and take on the world, even in its negative aspects. Affirmation produces a sense of belonging and an understanding of the common world "we" are sharing, through the multiple ecologies—natural, cultural, affective, and heterogeneous—that constitute us.[8]

This dynamic symbiosis is all the more relevant because contemporary subjects are internally fractured, techno-logically mediated, and globally interlinked. "We"—the dwellers of *this* planet at *this* point in time—are united by economic globalization and digital networks, but divided by socio-economic fractures and polarizations in wealth and access. The rise of populism and xenophobia, fascist and racist violence, also divides us, exacerbates our differences, and encourages aggression.

The aim of affirmative ethics is, therefore, not the pursuit of naive harmony. The point is rather to extract energy for collective action from social conditions that offer none. Dialectics is one manner of dealing with this problem, by fueling the energy for political resistance through opposi-tion, negation, and the antagonistic drive for recognition. Affirmative ethics takes a less violent path by acknowl-edging that the present is impoverished in terms of trans-formative options. It consequently borrows its dynamic energy from the future, so to speak. It mobilizes collective power (*potentia*) to counter-actualize alternatives that are both untimely and necessary—like injecting hope into a socially-depressed field or turning exhaustion into an opportunity for radical transformation.[9]

Affirmative ethics aims at undoing historically sedimented determinations of privilege and releasing transversal lines of transformation, not integral lines of power. There is an undeniable tension at the core: how to engage in affirmative ethics, which entails the creation of sustainable alternatives geared to the construction of social horizons of hope, while at the same time enacting resistance and opposition to the present? How does one become worthy of these times, so as to engage with them in a productive, albeit oppositional and affirmative manner?

Affirmative ethics as a collective practice confronts this tension and defeats the deceptive optimism of advanced capitalism. It constitutes a robust alternative to the state of disenchantment so many critical thinkers experience today.

A Non-Fascist Ethics

The *zoe-*/geo-/techno-mediated unity of living matter that I advocate does not deny differences as much as repurpose them outside the dialectical scheme. Differences are not oppositional, but rather modulative processes of individuation within a common matter. This is not a flat ontology, but a materially embedded, differential one, where differentiation is provided by non-dialectical practices. They range from collaborative evolution[10] to heterogeneous alliances,[11] indexed to the pursuit of affirmation.[12] This practice is primarily ethical, while its effects are political.

Consequently, neo-materialism is not an undifferentiated vitalist system that would organize species, technologies, and organisms under one common law, regulating them hierarchically. Such a holistic approach was the error of the organicist philosophies of life developed in the first half of the twentieth century. Some of them fed into the

exclusionary and imperialist interpretations of a sexual-
ized and racialized hierarchical natural order of domina-
tion that informed European fascism. Classical vitalism
was also associated with the pseudo-spiritualist cele-
bration of a cosmic soul or mystical spirit, leaning toward
esoteric and often obscurantist organicist ruminations.
Fascist forms of vitalism, moreover, were both opposed to
and seduced by the life-and-death force of technological
mechanicism.[13]

This is not the way in which the term "vital matter" entered
the posthumanist debate in the twenty-first century; far
from it. To begin with, contemporary technology does not
fit the modernist picture of romanticized, yet instrumental,
otherness. It has become far too intimate and coextensive
with human neural, cognitive, and emotional functions.

Moreover, a neo-materialist approach advances a serious
critique of the historical experience and the philosophical
roots of European fascism.

Affirmative critical thought is committed to detoxifying
the practice of philosophy from the appeal of method-
ological nationalism and the violence of authoritarianism.
It does so in two significant ways: firstly, by criticizing the
collective desire for power defined as the naturalization of
inequalities through the establishment of sexualized and
racialized hierarchies; secondly, by introducing heteroge-
neity and heterogenesis at the conceptual core of what
used to be called nature.

In this perspective, any individuated or specified organism
can be seen as bounded yet dynamic. As a modulation
within a common differential matter, it is a reduced
actualization of virtual inhuman and non-human flows
of becoming. Rather than glorifying or even sacralizing

a transcendent notion of "life," this neo-materialist approach stresses immanence. While emphasizing the generative power of living systems,[14] it radically proposes that there is no *one* system of life, just ongoing flows and transformations of forces. Life is a complex general ecology of multiple *zoe*-/geo-/techno-relations sustained by transversal modes of assemblage that define reciprocal forms of specification.

This non-unitary vision of living matter is not only important in relation to the past. It also acts as an antidote to contemporary micro-fascist formations. Vital neo-materialism is relevant today because it supports the recomposition of the human/non-human nexus by inscribing the technological apparatus as second nature, while avoiding an essentialist approach to any of those terms. "We-Are-All-In-This-Together-But-We-Are-Not-One-And-The-Same" is the formula that best expresses the relational frame of posthuman ethical subjectivity.[15]

"We," Just A People

The heterogeneous positions generated by embodied and embedded perspectives keeps at bay two fallacies: a naturalistic or holistic sublime on the one hand, and flat ontology on the other. I seek new milieus, new middle grounds, composed by heterogeneous multiplicities, both human and non-human. Affirmative ethical subjectivity does not refer to "the people" as a unitary category, self-constituted as "we, the people."

The people are not one, not only because they are a quantitative plurality, as political philosopher Hannah Arendt recommends,[16] but also on qualitative grounds. *A* people is rather a heterogeneous multiplicity that cannot coalesce into unity on pre-given grounds, such as the claims to ethnic purity that have become a defining

feature of both historical and contemporary fascist, nationalist, and nativist political regimes. *A people is always missing and virtual*, in that it needs to be actualized and assembled around specific projects and activties. It is the result of a praxis, a collective engagement to produce different assemblages.

We are not one and the same, but we can and do interact together. The aggregating factor in the composition of a missing people[17] is neither the built-in oppositional energy of the dialectical struggle for recognition (the force of the negative), nor a shared experience of vulnerability and powerlessness (i.e., oppression by *potestas*). The binding force is not reactive, but rather active and affirmative. It starts with a shared understanding (or cartography) of the embodied and embedded locations that engender conditions of oppression and subjection. This is expressed in collective imaginings (figurations) that deploy the shared desire to enact affirmative and empowering (both as *potestas* and as potentia) alternatives. This affirmative ethics defines political subjects as transversal assemblages that are not given, but need to be composed and enacted. This, however, does not make them into mere performative utterances in a linguistic sense. Shared affirmative values and passions rather constitute materialist subject formations. They function as rallying-points or groundings for embodied and embedded, relational and affective encounters. Different perspectives cluster or coalesce around shared affects and communal actions that support the emergence of a specific "we" as a transversal agent. This is the collective project of composing just a people.

Affirmative ethics begins by brining about a community—a "We-Are-All-In-This-Together-But-We-Are-Not-One-And-The-Same" subject; "a missing people" assembled around

the shared desire to enact productive subversions of the status quo by actualizing virtual possibilities. This need not be an anarchic rupture: great ideas like freedom and democracy, for instance, belong to the category of the future past, in the sense that they have been around for a while but were never completely successful in their implementation. Their time is still to come. The function of affirmative ethics is to sustain the project of actualizing virtual possibilities. They defeat negativity on the one hand, interrupting the static and acquiescent replication of established norms and values, but on the other they also undo the paralysis induced by disenchantment. They actively prevent the exploitation of resentment and negativity by opportunistic political forces that feed on the negative in order to divide and conquer.

The affirmative drive to compose ethical, that is to say non-fascist, subjects assumes that humanity does not stem from intrinsic freedom, but rather that freedom is extracted cognitively out of the awareness of limitations. It is freedom through the understanding of our bondage. The capacity to understand both potentials and their limitations is affectively driven: an affirmative ethics helps increase the degree of relational power that all entities—including, but not limited to, humans—are capable of mobilizing and activating. Negativity reduces our relational abilities and disconnects us from the world. Consequently, affirmation is about the task of pursuing freedom as a transformative collective practice of turning negative encounters, passions, and relations into affirmative ones. Because all living entities are driven by *conatus*—the ontological desire to go on expressing the degrees of power (*potentia*) they actually embody—affirmative ethics aims to activate the collective desire to increase positive relationality.

Affirmative ethics starts with the composition of transversal subject assemblages—iterations of "we"—that actualize the unrealized or virtual potential of what "we" are capable of becoming. But "we" differ in this very capacity, so "we" are not becoming the same thing, not at the same speed, and not in the same place. This calls for collectively-managed processes of social transformation and the common construction of materially embedded differential perspectives.

Learning to Die by Living the Non-Fascist Life

Affirmative ethics is a social practice that mobilizes collective aspirations, as well as environmental and social resources. It functions by taking in and on the pain and shortcomings of the world in a transformative mode. The core issue is how to transform pain and suffering, notably the greatest grief of them all: death itself.

An affirmative position on death assumes that death is not the teleological destination of life, a sort of ontological magnet that propels us forward. Death is, rather, behind us. Death is the event that has always already taken place at the level of our consciousness of being mortal. As an individual occurrence, it will come in the form of the physical extinction of the body, but as event, in the sense of the awareness of finitude, of the interrupted flow of my being-there, death has always already taken place. We are all synchronized with death—death is the same thing as the time of our living, in so far as we all live on borrowed time.

The time of death as event is not linear. It is both highly personal—because nobody can die in your place—and distinctly impersonal, as it is universally shared by all that lives. The time span of death is time itself, the totality of

35

specifically-allocated time. In this respect, the question of dying is the same question as how best to live. This proximity to death is a close and intimate friendship that calls for endurance, in the double sense of temporal duration, or continuity, and spatial suffering or sustainability. Making friends with the impersonal necessity of death is an ethical way of installing oneself in life as a transient, slightly wounded visitor. We build our house on the crack, so to speak. The proximity to death suspends life, not into transcendence, but rather into the radical immanence of "just a life," here and now, for as long as we can and for as much as we take.

Death frees us into life. The desire to live (as *potentia*) seduces us into going on living. Living "just a life," therefore, is a project, not a given. Life is beyond pleasure and pain—it is a process of becoming, of stretching the boundaries of endurance. There is nothing self-evident or automatic about life. It is not a habit, though it can become an addiction: one has to "jump-start" life each and every day.

Thus, in contrast to the fascist glorification of the heroic death—the logic of martyrdom of the few and sacrifice of the masses—but also against the Christian hypocrisy that sacralizes "life" by indexing it upon a moral frequent-flyer system—I would like to turn to a more stoical, more lucid tradition of thought. A stoical disposition does not start from the assumption of the inherent and self-evident worth of "life." It rather approaches it as praxis, as perpetual self-styling in a multi-directional relational mode.

The posthuman convergence that frames the project of affirmative ethics entails the commitment to live an ethically affirmative life in order to learn how to die. In the context of the sixth extinction and the necropolitical

management of dying on a planetary scale, we need an updated and even sharper rendition of ethical ways of dying. While the marginalization and murder of stigmatized anthropomorphic others continues, the thought of death is extended to multiple non-humans. Death becomes a tool for rethinking the social, the political, and the ethical by a multiplicity of heterogeneous "we"-subjects that are materially situated on a differential planetary plane.

This affirmative ethics of dying also involves a reversal of the apocalyptic lament about catastrophe, and of the "white male, pale, and stale" catastrophic discourses that are so strong in anthropocene scholarship.[18] I argue for a different form of critique; an affirmative ethics born precisely from making friends with death. Affirmative ethics demands that we "live as if we were *already dead*," in a politicized space of alternative subject figurations. We need to learn to live as if our world had already gone, as if we had become a thing: the becoming-corpse of our bodies is accepted as part of the deal. We need to learn to live with multiple worlds that are dying, not all of them human. Such a disposition requires theoretical food for thought, in ways that feminist materialist epistemologies, for instance, propose. Postcolonial, Black, and indigenous perspectives are also essential in relaying the lessons of those "others" whose worlds have ended before, destroyed by racism, slavery, patriarchy, and capitalism. And yet, they have learned to live again and to endure in alternative ways of relating to the earth. What is needed are careful renegotiations of transversal alliances across materially grounded differential perspectives, and also across human and non-human agents and across species, while accounting for the ubiquity of technological mediation.

What I am arguing for is a neo-materialist, planetary, differential affirmative ethics that calls on us to live up to

the *intensities* of life, to be worthy of *all that happens to us*. This is a posthuman position in which we find ourselves; a planetary interconnection of being in this damaged, endangered, globalized, technologically-mediated, and ethnically diverse world "we" inhabit, "together but not as one."

1: Klaus Schwab, "The Fourth Industrial Revolution," *Foreign Affairs*, 12 December 2015, https://www.foreignaffairs.com/articles/2015-12-12/fourth-industrial-revolution.

2: Elizabeth Kolbert, *The Sixth Extinction* (New York: Henry Holt Company, 2014).

3: Michel Foucault, preface to *Anti-Oedipus: Capitalism and Schizophrenia*, by Gilles Deleuze and Félix Guattari (New York: Viking Press, 1977); and Rosi Braidotti, *Patterns of Dissonance: On Women in Contemporary French Philosophy* (Cambridge: Polity, 1991).

4: Gilles Deleuze, *Spinoza: Practical Philosophy* (San Francisco, CA: City Lights Books, 1988); and Pierre Macherey, *Hegel or Spinoza* (Minneapolis: University of Minnesota Press, 2011).

5: Genevieve Lloyd, *Spinoza and the Ethics* (New York: Routledge, 1999); and Rosi Braidotti, *Transpositions: On Nomadic Ethics* (Cambridge: Polity, 2006).

6: Stacy Alaimo, *Bodily Natures: Science, Environment, and the Material Self* (Bloomington, IN: Indiana University Press, 2010).

7: Rosi Braidotti, "A Theoretical Framework for the Critical Posthumanities," *Theory, Culture & Society*, 4 May 2018, https://doi.org/10.1177/0263276418771486.

8: Félix Guattari, *The Three Ecologies* (London: Athlone Press, 2000).

9: Rosi Braidotti, *Posthuman Knowledge* (Cambridge: Polity, 2019).

10: Lynn Margulis and Dorion Sagan, *What Is Life?* (Berkeley, CA: University of California Press, 1995).

11: Donna Haraway, *Staying with the Trouble: Making Kin in the Chthulucene* (Durham, NC: Duke University Press, 2016).

12: Braidotti, *Transpositions*.

13: Filippo Tommaso Marinetti, "The Founding and Manifesto of Futurism (1909)," in *Futurism: An Anthology*, Lawrence Rainey, Christine Poggi, and Laura Wittman, eds. (New Haven, CT: Yale University Press, 2009), pp. 49–53.

14: Keith Ansell Pearson, *Viroid Life: Perspectives on Nietzsche and the Transhuman Condition* (London and New York: Routledge, 1997); and Keith Ansell Pearson, *Germinal Life: The Difference and Repetition of Deleuze* (London and New York: Routledge, 1999).

15: Rosi Braidotti, *The Posthuman* (Cambridge: Polity, 2013); Braidotti, "Theoretical Framework"; and Braidotti, *Posthuman Knowledge*.

16: Hannah Arendt, *The Human Condition* (Chicago: Chicago University Press, 1958).

17: Rosi Braidotti (in conversation with Maria Hlavajova), "A Missing People," in *Former West: Art and the Contemporary After 1989*, Maria Hlavajova and Simon Sheikh, eds. (Cambridge, MA: MIT Press, 2017), pp. 571–580.

18: Timothy Morton, *Hyperobjects: Philosophy and Ecology After the End of the World* (Minneapolis: University of Minnesota Press, 2013); and Roy Scranton, *Learning to Die in the Anthropocene* (San Francisco, CA: City Lights Books, 2015).

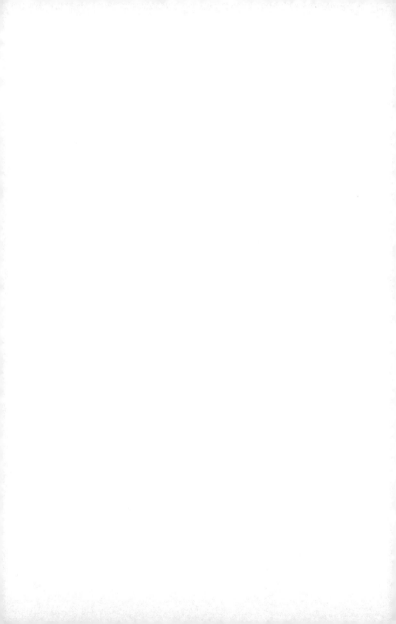

Notes on the Underside of Visibility

Denise Ferreira da Silva
(in conversation with Jota Mombaça
and Thiago de Paula Souza)

Jota Mombaça and Thiago de Paula Souza: In recent years, the political and social landscape of Brazil—the country each of us is connected to in various ways—has suffered dramatic changes. If the Brazil of the early 2000s was floating on hope and excitement, with the promise of a whole new future ahead, it is now much more arduous and painful to imagine what might come after the triumph of the current populist regime. We want to touch upon how the Brazilian debate on affirmative action in this era reflected the ways in which the social reforms of both the Lula and Dilma Rousseff administrations, at a time of growth and prosperity, sought to reorganize the economy of access and the power dynamics in the country. Yet these reforms were not enough to combat successfully the violence and inequality that were present at its foundation and have lingered throughout its history. It is in this context that we would like you to revisit some of your key ideas, even if in fragmentary fashion, and think through conceptual, propositional tools that might be available to artists, intellectuals, and activists in the face of the conditions that define the present. We would like to speak about the problematic aspects of critique and representation, but also about the paradoxes of visibility politics in the neoliberal present that produce the appearance of emancipation while simultaneously creating the conditions for the emergence of new forms of control and extraction.

Denise Ferreira da Silva: Perhaps one of the most problematic aspects of critique is how, precisely because it exposes the force of representation (or what I call the political-symbolic moment of modern power), it gives the impression that exposure is enough, that there is not much more to be done to "resist" power. The problem is that critique issues from the same source as representation. And, for this reason, it cannot itself undo that which makes it possible in the first place.

Further, as you correctly point out, capital has this ability to render everything a commodity, and that includes resistance and its props. For many of us—well, for most of us Black, indigenous, queer, trans, female folks, especially those from economically dispossessed families—who have entered the global (artistic and academic) markets in the past 30 or 40 years or so, there is the added fact that, in order to pay our (and ours') bills, commodification of one's image seems inescapable.

I think that it is about time we put critique in its place, taking advantage of what it has to offer but also exposing its limits. For instance, it is only the assumption that the principles of equality and liberty (self-determination) are universal and have always contemplated "others" of the property-owning, cis-heterosexual white male that sustains the fantasy that once the former ("others") are rendered *visible*—included or represented—the modalities of subjugation that constitute the latter's power will some-how dissipate. Visibility, imagined to occur under white light (the visible range of the electromagnetic spectrum), is a ruse. Because transparency is equivalent to invisibility, the presumed identity between whiteness and universality (a referent of transparency) responds to the former's symbolic force as a racial category.

It follows, then, that for those of us placed on the under-side of the dichotomies that sustain the property-owning cis-heterosexual white male (transparent/universal) subject, the most obvious move would be to make things visible; to expose every aspect of the global context, every institution of the social, every juridical, economic, and symbolic mechanism, process, structure, and all the ontoepistemological tools, every discourse, and every kind of modern text—to reveal all that produces transparency. Not, however, under white light. For one thing, white

light only shows that which is recognizable, that whose contours are already named. In other words, white light illuminates (clarifies, elucidates, explains); it is saturated by—because it is the privileged signifier for—transparency (clearness, lucidity, intelligibility). Do you see what I am getting at?

I have elsewhere developed a device, which I call "black-light," for reading philosophical and theoretical constructs, primarily critical ones, such as Marx's "materialist conception of history." Blacklight works by foregrounding the components of a statement that are relegated to an insignificant role in its construction and effect. For instance, I apply blacklight to Marx's equation of value as presented in "The Labour-Process and the Process of Producing Surplus-Value," from *Capital, Volume I*. What blacklight does in the reading is to make the commodity of cotton shine in the description of the theory, thereby making it possible to contemplate colonial production—that of expropriated slave labor applied to the cultivation of expropriated indigenous lands. By projecting blacklight it is possible to expose the obscurations (which white light always produces) that limit the proper meaning and even application of a given concept or thesis. In the case of Marx's equation of value, blacklight exposes how the critical program that finds labor time as the sole source of exchange value is sustained by a juridical distinction, that between contract (among capitalists and wage laborers) and title (of the owner over the slave's body). Where deconstructive tools are designed to expose constitutive aporias, blacklight is closer to conventional tools of analysis in making it possible to redeploy the very concept, statement, or thesis by turning it inside out or by expanding it.

JM/TdPS: Under the Workers' Party (*Partido dos Trabalhadores*, PT), we witnessed an explosion of

different visibility policies in Brazil and, as a result, a fiercer clash of forces. An emblematic moment was the 2006 "Manifesto against the Quotas" that was signed by a group of (mostly white) Brazilian intellectuals who strongly opposed the affirmative action policies established by the federal government.[1] It's not really a surprise that these scholars and artists positioned themselves this way, even if many of them had critiqued the Atlantic slave trade, slavery in Brazil, and all the violence that constitutes the pillars of the Brazilian state in their work. At that moment, their main argument was that the quotas would divide the country, as if the country hasn't been always divided. Of course we acknowledge the limits of quota politics in Brazil; but we also understand that the very aim of those public policies was to start a reparatory movement toward those of us who had been excluded from the higher education system. The quota system was a small gesture that has already produced changes in how knowledge is developed and has raised intense debates concerning the economies of social access in the country. Could one imagine possible ways of operating while surrounded by people who insist on reproducing their colonial fantasies as a normative principle of social pragmatism?

DFdS: During the many years over which the affirmative action debate unfolded in Brazil, I was amazed and annoyed by how unintelligent it was, and by how little interest both sides had in its general global-historical context. I wrote two pieces about it: in "The End of Brazil," I tried to map the versions of the liberal discourse that were clashing.[2] On one side of the affirmative action debate, which unfolded very early in the process of the policies' implementation, those against them deployed

the formal figure of the citizen, who is entitled to the protection of its property and rights. On the other, those defending the policies mobilized a figuration of the citizen as the social (racial, gendered, sexual) subject. In a second article, "The Racial Limits of Justice," I described the ways in which policies of social inclusion and poverty alleviation (in Brazil and elsewhere) had been deployed hand-in-hand with the assembling of the security state—which is the one that now prevails in Brazil.[3]

Whatever strategies we devise to respond to the present circumstances in Brazil, with a government that has (at every level) basically abdicated of all the tasks once assigned to the (protective) institutions of the modern nation-state, we cannot repeat the mistakes of the affirmative action debate. We cannot accept the Right's terms, which kept the conversation within the logic of the Brazilian national text and pre-empted arguments that situated what was then happening in Brazil as part of a larger global reconfiguration which met the needs capital had at that moment.

Today we cannot ignore that the Brazilian Right is supporting—and will be supported by—the dismantling of the democratic infrastructure which, could, at times, restrain colonial, racial, and cis-heteropatriarchal violence. More importantly, I think, it is good to acknowledge that the affirmative action programs of both the Lula and Dilma Rousseff's administrations, as well as their policies supporting cultural and artistic sectors, have formed at least two generations of artists, curators, and academics, that is to say, thinkers—like you—who are equipped not only with the necessary intellectual tools but also with motivations that have no commitment to what I will call here the "Brazilian discourse on affirmative action." Nor do you, unlike my generation, have to deal with a

Left (communist or socialist) that resisted attending to anything besides economic exploitation. Also unlike my generation, you don't need to rely on cultural difference in order to demarcate a place for critical intervention.

We, and here I include those of my and other generations who are willing to fight, must be in the position to respond to the Right without fantasies of revolution, inclusion, and representation. Of course, there is the urgency that will move us, at the same time, to a) do all that we can to halt the Bolsonaro administration's security strategies, which are designed to obliterate (Black, queer, indigenous, trans, female) people; b) denounce the killers and fight for their prosecution; and c) live in a world where this kind of total violence is the rule *as if* it had already come to an end and we had all that we needed in order to *know* the world otherwise.

> **JM/TdPS:** The end of the world as we know it appears in your writings as some sort of liberation process, or at least as the condition for the emergence of another world in which the modern-colonial effects of violence are no longer constitutive; as a way of performing fugitivity and refusal beyond the borders of subjectivity and/or representation. How to destroy the world as we know it?

DFdS: Let me just say a few things about the end of the world as we *know* it. First, I don't think the call is for liberation. I am really not interested in the principle of liberty. Liberty is the main principle guiding our current knowledge of the world. Thus if this way of knowing the world is to end, liberty will have to go first, precisely because it provides the ethical support for colonial, racial, environmental, and cis-heteropatriarchal total violence. It is not a call for liberation, if it is understood

as the establishment of a self-determined position in the world, and in relation to the other humans in it. That is the primary meaning of the concept of liberty, which is the key concept in modern thought. My argument has been that this understanding of liberty and self-determination is at the basis of the fundamentally violent orientation of modern thinking and the juridical, economic, and ethical architectures it sustains. So, yes, the end of the world as we know it means the dismantling of this modern grammar and lexicon.

I have to insist that this not be taken solely as a critical statement on liberal thought. Of course, the concept of liberty defines liberal thought but it also supports its "opposite," the modern conservative alternatives such as Nazism, fascism, and all the varieties of white nationalism. Liberty and equality organize the field within which these are distinguishable, because they make the "liberal" and "the conservative" positions imaginable and intelligible.

The point is then to assemble strategies for knowing the world differently. But this is not just for the sake of knowing. Knowing the world differently, knowing the world otherwise, is both the precondition and also an outcome of the end of the world, that is to say, decolonization, which is the return of the total value extracted from native territories and expropriated from slave bodies. (Please note that the terms "value," "territory," and "body" belong in the modern juridical-economic vocabulary and that "native" and "slave" are also modern—that is to say, colonial—juridical-economic subjects.)

Knowing the world differently will require an image of *justice* that is not framed by the principles of liberty and equality. More importantly, such an image of justice will also make untenable the reactionary return to fascist

and white-supremacist principles of identity and purity. The recurrence of the latter can only be avoided if liberty and equality cease to be the only available supports for political discourses that denounce and counter the mechanisms deployed to sustain capital. We need to know and exist in the world differently. Only an image of justice without these principles will be able to stop the destruction of the world by global capital and its agents. We need to bring to an end the way we know the world currently, before it truly brings about the end of the world and everything that exists in it.

1: Vânia Penha-Lopes, *Confronting Affirmative Action in Brazil: University Quota Students and the Quest for Racial Justice* (Lanham, MD: Lexington Books, 2017).

2: Denise Ferreira da Silva, "The End of Brazil: An Analysis of the Debate on Racial Equity on the Edges of Global Market Capitalism," *Columbia University National Black Law Journal*, vol. 1, no. 1 (2010), pp. 1–18.

3: Denise Ferreira da Silva, "The Racial Limits of Social Justice: The Ruse of Equality of Opportunity and the Global Affirmative Action Mandate," *Critical Ethnic Studies*, vol. 2, no. 2 (Fall, 2016), pp. 184–209.

Plantocracy or Communism

Stefano Harney and Fred Moten

1.

You can imagine it is difficult for those of us coming out of the black radical tradition to embrace the currently popular timeline on fascism. If fascism is back, when did it go away? In the 1950s, with Apartheid and Jim Crow? In the 1960s and 1970s? Not for Latin Americans. In the 1980s? Not for Indonesians or Congolese. In the 1990s? The decade of intensified carceral state violence against black people in the United States? We do not mean to deny the resurgence of fascism in parts of Europe, but we can say something about the fundamental difference between common life and undercommon living precisely because we adhere to the black radical tradition's expanded sense of fascism's historical trajectory and geographical reach.

The idea of the commons as a set of resources and relations that we, as otherwise exploited and expropriated people, build or protect, manage or exploit, follows from several assumptions. First and foremost is the assumption that we could ever be anything but already shared and already sharing. Indeed the condition of our ability to share is that we are shared. In other words, we are not individuals who decided to enter into relations through the commons. The commons cannot gather us. We are already gathered, as we are already dispersed and interspersed. The idea of the commons leads to the presumption of interpersonal relations, and therefore of the person as an independent, strategic agent. Such persons make not just commons, but states and nations, in this worldview.

The undercommons is the refusal of the interpersonal—and, by extension, the international—upon which politics is built. To be undercommon is to live incomplete in the service of a shared incompletion, which acknowledges

and insists upon the inoperative condition of the individual and the nation—as these brutal and unsustainable fantasies and all of the material effects they generate oscillate in the ever-foreshortening interval between liberalism and fascism. These inoperative forms still try to operate through us.

If the undercommons is not the commons, if the new word implies something inadequate about the old word, it is that the undercommons is not a collection of individuals-in-relation, which is precisely how the commons has traditionally been theorized. In formulating the undercommons, we were trying to see something underneath the individuation that the commons bears, hides, and tries to regulate. It is what is given in the impossibility of the one *and* the exhaustion of the very idea of the one.

2.

What would happen if every time people use the word "university" it came out sounding like "factory?" Why do people think working in the university is special? We're not saying that it's not special. We're wondering whether the reasons some people think it's special are bad. The university was a gathering of chances and resources; a cache of weapons and supplies; a concentration of dangers and pitfalls. It's not a place to occupy or to inhabit; it's a place to work, to get in and out of with such rapidity and purpose that its boundaries disappear. All of that work ought to be directed toward securing the capacity to use those resources and to take those chances and to pass them around to the extent that they are useful. The university is not a point on a line. It's not an aspirational beginning or end; it's a respirational organ that is all but certainly laced with malignancy. It requires us to consider, as if it actually had something to do with us, what farmworkers think of working on a farm before that activity is congealed into

the achievement of the identity "farmer." In this regard, the undercommons *is not*, except incidentally, about the university and the undercommons *is* crucially about a sociality not based on the individual. Nor, again, would we describe it as derivative of the individual; the undercommons is not about the sub-individual, or the pre-individual, or the supra-individual. The undercommons is an attachment, a sharedness, a diffunity, a partedness. If we mentioned the university at all, it was because it was the factory we were working in when we made our analysis.

This is all to say that the undercommons has no particular relation to, or relative antagonism with, a sector created by the capitalist division of labor called higher education. As Marx said, the criminal creates the criminal justice system. We find "informal and situated knowledge" among prisoners, prisoners' families, courtroom clerks, and reporters, etc. This undercommon work is what the legal sector exploits. Lawyers and judges are primarily supervisory. Likewise it is the healing work of patients and families that makes the health sector. Doctors and nurses are primarily supervisory. And so, beyond all the ideology of the special mission of the university sector it is worth remembering two things. First, students make the higher education system. Professors are primarily supervisory. Second, students working to become teachers, in any area, are—all of them— being groomed for management. Graduate students feel this contradiction and it hurts, because they are moving from the shop floor to management. But the fact is that if you want to teach for money in our system, you're supposed to supervise. None of this would need saying if we were talking about the automobile sector. Those who work in an auto plant know their roles. If they solder, they are workers. If they evaluate the quality and speed of soldering, they are management. Of course, managers get evaluated too, and, sometimes, something like an appetite for being (de)graded,

which accompanies the appetite for (de)grading, appears to appear. But that's small-scale compared to the mechanics of "teacher-student relations," which study refuses.

Of course, part of the ideology of the university's exceptionalism is that under this capitalist division of labor the university is permitted to gather knowledge of, that is, to supervise, not just its own sector and its students, but also other sectors. It creates agronomy departments to share in the supervision of the agricultural sector, or art departments to share in the supervision of the art market, through research. But this should not fool us. It is the same for the banking sector, whose oversight and supervision of other sectors produces papers and reports.

Realizing that you have to supervise to teach for money, even lousy money, in our system can then lead to two forms of collective organization. We can take from the job our money and do something else together, or we can work to overturn a system that chains study to supervision because only this overturning is going to break that line. And at a certain point, since any exodus both goes nowhere and undermines what it leaves, these two forms of organizing come together. Any other approach is just waiting around to be offered "supervisor of the month" or a "Distinguished Teaching Award."

3.

This situation might be clarified by exploring the term "complicity." As we often suggest around the practice of study, once we try to do so, the system will come for us, no matter how minor our study appears to us. And so, there is really no possibility of disengaging given the constant potential we carry to provoke engagement. Life demands we bring forth this potential again and again despite the consequences.

But engagement itself also posits and re-posits us in a way that risks trapping us in an idea of ourselves as strategic agents who have antagonistic relations with systems of power. But what we have called a general antagonism does not admit strategy, nor strategic relations, nor strategic agents. In fact, it points to the fundamental antagonism of all *as* difference: clashing, contrasting, emerging, and fading without agents or strategies. Agents with strategies—that is, individuals—mistake all this difference for something out of which they can fashion choices, or decisions, or relations, which is also to say out of which they could fashion themselves. But the general antagonism won't let you go, no matter how hard it propels you, 'cause it's us. Your efforts at recognizing yourself and being recognized will riot on you.

This is why we find complicity useful. When you think about how people worry about complicity, it is precisely a fear of the general antagonism. If someone is worried, as is typical, of how their art practice or curatorial practice will be compromised by complicity with the museum, or worried about how their research and teaching will be compromised by complicity with the university, at the base of that worry is the fear that they cannot sort themself out in the midst of this complicity. The person cannot say this is "me," my strategy and my relation to the institution. Complicity indicates a kind of falling into something and not being able to disentangle what you see as yourself from the institution and its (anti-)sociality. The person fears not being able to say *this* is the boundary, fears that the border is crossing them. But no number of strategies, decisions, or relations can disentangle us. The institution seems so much more successful than us at turning the general antagonism into the ground for individuation. But why do we feel this way when the real feeling we get from the institution is precisely the opposite: entanglement?

Now, maybe the way to deal with that resistance to the general antagonism provoked by the fear of complicity with an institution is to invoke the other use of complicity. To be complicit with others, to be an accomplice, to live in ways that always provoke conspiracy, a conspiracy without a plot where the conspiracy *is* the plot—this use of complicity can help us. This second use of complicity emphasizes our incompleteness—when you see us you see something missing: our accomplices, or something more, our conspiracy. It's all good, it's just not quite all there. We don't make sense on our own. There must be more of us, more to us. On our own we don't add up. And that is what we are, and that is what we are in the institution, and how we are in the institution, complicit with others who are not there in the institution, conspiring with them while inside, tangled up in the institution with the thought or the sound or the feel of the outside, which is in us, which we share in this sharing with, this ongoing folding with, this inaccomplishable *com + pli*. That kind of complicity can be deepened even as we deepen our place in, as we dig down through, the institution. We can provoke here not a strategy of within and against, but a way of living that is within and against strategy, not as a position, a relation, or a politics, but as a contradiction, an embrace of the general antagonism that institutions feed off but deny in the name of strategy, vision, and purpose. Our complicity is its own purpose, and the more it grows the more the underlying entanglement of the institution overwhelms its strategy. We will have been violent to, or malignant in, the institution; cutting it together apart into nothingness, as feminist theorist Karen Barad might say.

Another word for this is communism. We can't be spoken of in the same breath as the League of Black Revolutionary Workers, but we can try to follow their example insofar as it doesn't seem that they indulged

in a lot of handwringing and navel-gazing regarding their complicity with the auto industry. They didn't feel guilty or conflicted about working for General Motors. They didn't identify with GM or derive their identity from their relative antagonism with GM. Sometimes we are asked by graduate students if we feel hypocritical about being "career academics." Did labor organizer General Baker of the League of Revolutionary Black Workers—after whom, we might say, and we'd only be half-joking, the general antagonism is named—feel hypocritical about being a career autoworker? We'd rather answer such questions by saying why we can't answer them. We study with General Baker and the great black studies scholar Cedric Robinson, even now, and they share how they refuse the metaphysical foundations of politics and political theory. We study with Audre Lorde and Michel Foucault, too, but centering her pre-emption of his recognition of "the fascism in us all" doesn't rid us of the task of reading—by way of them, in their wake, under their influence and protection—against the grain of their metaphysical/political commitments to individuation, which each of them articulates by way of a certain "care of the self." What if what's always being taken care of is not this or that particular self but the idea of the self that lies at the core of anti-socially reproductive carelessness? We said non-fascist living is a refusal of communism. It is. It is a refusal of complicity. It is an impossible ethics of individuation-in-relation. Individuals must, but at the same time cannot, be in relation. Increasingly, we live and suffer contradiction as the genocide, and geocide, we study to survive. We want to share in that study.

4.
Let's imagine that Foucault shared a problem with us, and that problem was the metaphysical foundations of politics. That metaphysics says that there are individuals

who bear rights and morals that must be protected by the state. Politics is the way those individuals then relate to each other, to their own selves, and to the government. That government emerges from within this politics but also, as it were, from outside of this politics by way of an authority whose foundations are not only, as philosopher Jacques Derrida says, mystical but also in and of a hard, brutal, real(ist) presence. Foucault, of course, did not believe in this metaphysics. He thought the individual, who will have been protected by the state but was in fact created by the state, was a prison house, but one created so subtly and seductively that we would open the door to it ourselves. His tactic was to refuse this individual in favor of a self that would be tended to, directly, by the animate body concerned. Now, we want to share Foucault's refusal of the metaphysical foundations of politics that we nonetheless often find ourselves trapped within. We share that refusal, in fact, whether we want to or not. That is the first sense of our complicity, that sharing, which is a sharing of and in desire. It's just that it is a sharing that is not—either in the first instance or the last, because there is neither first nor last—embodied. Sharing is, as Hortense Spillers teaches us, from within the field of black feminist theory and practice that also provides for Lorde, a fleshly animation that moves disruptively in, while also surrounding metaphysico-political individuation; or, if you will, the body politic. We share, in complicity, that movement within that also surrounds. It is not that what we want is bound up with politics. It is that we find ourselves reduced or stayed by politics and having to fight our way "back" to something else that is uncontained by it. But that something else cannot be found by taking the path Foucault cuts, because that path, which is the animate body's path, has always been denied to the flesh, and therefore most especially to black people, who are for historical reasons disentrusted with the keeping of what

becomes what it always was: blackness, that anoriginal communism, which novelist and educator Toni Morrison speaks of not as the care of the self but as the love of the flesh. Refusing the "selves" and "bodies" refused to them, black people live in the duress of (the state's or racial capital's political body's) total access to what they protect but do not have, which is and must remain as the absolute vulnerability to valuation, grasp, and possession of the absolutely invaluable, ungraspable, and dispossessively dispossessed. Therefore, if you follow in the swerving path of this access, which must be kept open at the price of being left open, you have to, and you do, find another way.

For us the refusal of (the) metaphysics that we share with Foucault, that Foucault's brilliance lights in us, must nonetheless depart from his path, as it continually departs from its own in its fugitive flight from freedom, slavery's afterlife and unwilling informant. Therefore, we have to question both the metaphysics of the individual and of relations, and, indeed, of the (inter)personal.

Marx wanted us to organize our powers as social powers, and he warned us that so long as we divided our social powers from ourselves in the form of political powers, we would not emancipate ourselves. But the problem extends further when we come to understand that the only conception of emancipation we can have is a political one. And so, we have to work on and for a communism that does not resolve itself into freedom or emancipation after having done all that work against the political. And the way to do that is to shift Marx's formulation under the guidance of those whose emancipation is behind them, and in hot pursuit. Otherwise we would be subjugating ourselves to each other through individuals-in-relations of emancipation, the very free subjects

who can do nothing but privatize, externalize, and brutalize as, indeed, free subjects always have. Instead, we can imagine an entanglement of life, and constant bloom, amid an earthy decay. We can imagine it because it happens everywhere social life surrounds the political life that seeks to separate us from our powers by offering us power, or worse, the right to demand a share of what we are forced to make and cut to meet the conditions of the demand. We can imagine it, the anoriginal communism, because it's lived wherever blackness militates against itself—wherever, as Sly Stone says, there's a riot going on. And unfortunately we can imagine it because the regulatory force of politics, individuals, and relations between supposedly discrete and sovereign humans is, as Robert Johnson says, a hellhound on our trail.

5.

The act of emploting yourself in time and space is— perhaps paradoxically at first—also the act of being all but nowhere. That spot that you mapped is dimensionless. It cannot be found precisely because your act claims that the point you will have occupied is the universal point, the abstract point every individual can and must make and from which humanity becomes possible, with and through, and in which the human finds themself. And because it is nowhere, its relationship to place is, in fact, one of impunity. It is this impunity that founds modern morality and the idea of responsibility or sustainability, which this act of impunity then hires as its security detail. And can there be a better description of the human: the being who lives with impunity on the earth and is sorry about it? So, the question of what has happened can be taken with the question of what will happen. Because against the abstract preparation for the victory of reason over its rivals, this tilting of the board toward one point, there is a way to

live history and place that is not part of the humanization, that is to say racialization, of our earth and its reduction to the world; does not participate in humanization's degradation of its means to mere logistical ends and its loss or forfeit of sharing to mere ownership, all of which require and are instantiated by emplotment and its rule(r). The poet and critic Amiri Baraka calls this entanglement of history and place "place/meant" and it is as if he meant for that errant and supplemental "a" to signify a movement of and in place, a radical and irreducible movement that constitutes our undercommon indigeneity, our shared, native, ante-natal turning and return. If emplotment is how we give up the undercommons for a common grave, then place/meant is how we find and mark the surrealistic spot.

Black imagination in the face of fascism is certainly an example of living history and place without succumbing fully to emplotment, but this is not to say that it is living in some form of real life that's more "real." That's not the point. It's not even about the point and it's not about pointing. Some of the earliest speculative fiction we have is black speculative fiction written in response to US-American fascism, and it's part of what is now the longest running and perhaps most successful, which is to say unsuccumbed to "success," of the earth's anti-colonial movements—the struggle by black people against the fascist colonial order called the United States of America. From abolitionist-journalist Martin Delany to science-fiction writer Octavia Butler, emplotment is continuously disrupted in the name of movement. And we could also point to the continuous non-coercive re-arrangements of desire, to turn with literary theorist Gayatri Spivak, that constitute black music, which is neither metaphor nor allegory, nothing but generally ante-generic black social life as it brings around its history and mashes up its place again and again.

This is what tells us that the answer to how to act is how we act. It's historian and revolutionary C.L.R. James's future in the present, which is this train Sister Rosetta Tharpe is always talking about, that clean one Woody Guthrie sleeps on, as a pillow, Gladys Knight's midnight train, The O'Jays's friendship train, Trane's sun ship, Sun Ra's and Funkadelic's spaceship, the general blinds we ride. Time and space emplotment is fundamental to every capitalist production process, to all the circuits of production, beginning with the production of the human worker. Bending time and space to our offbeat beat and displaced place is bound to fuck that up, 'cause it already will. Now, if you need some, come on, get some, before it's too late. As long as you don't steal, we share.

The Thread and the Gap

Patricia Kaersenhout
and Lukáš Likavčan

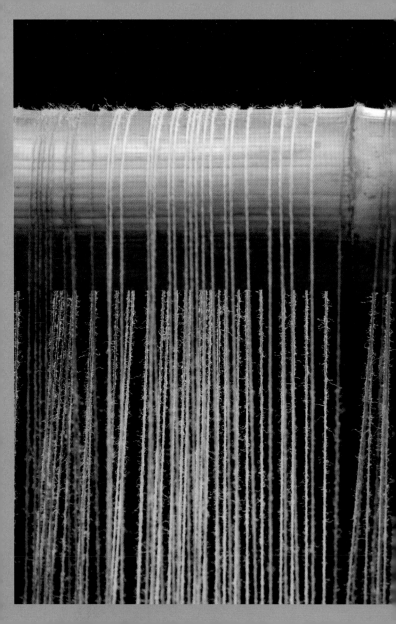

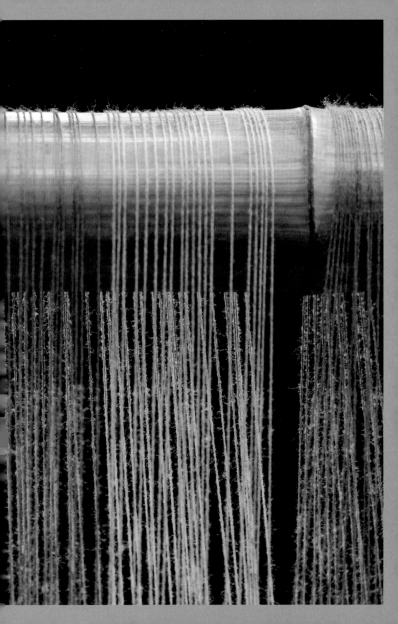

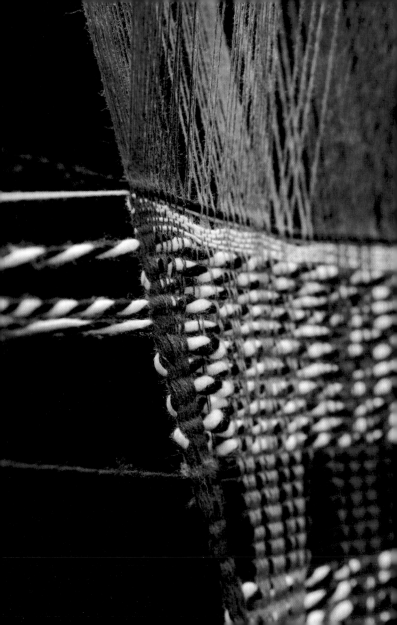

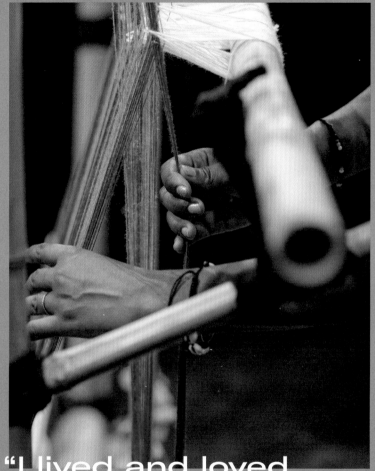

"I lived and loved,
some might say, in
momentous times,

looking back, my dreams were full of prisons

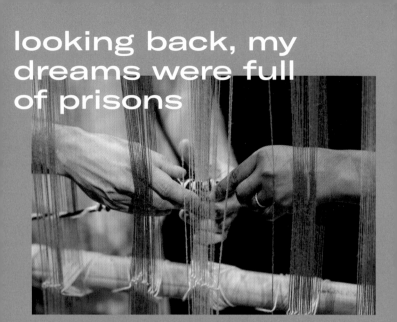

my every waking, was incarcerated

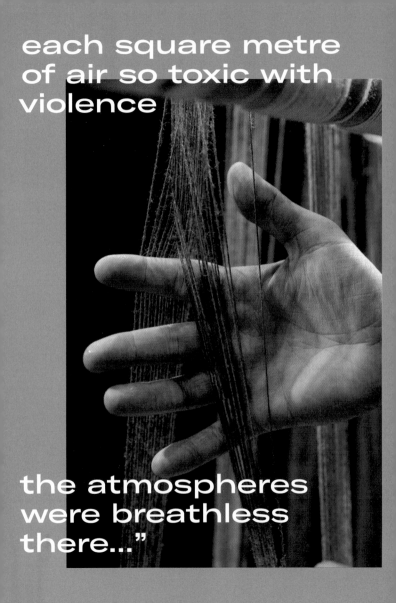

each square metre
of air so toxic with
violence

violence

the atmospheres
were breathless
there..."

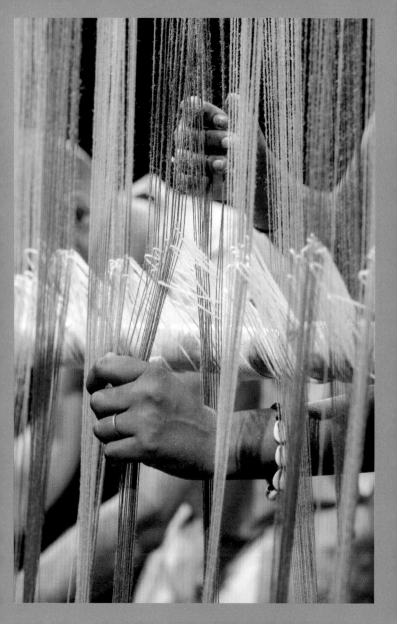

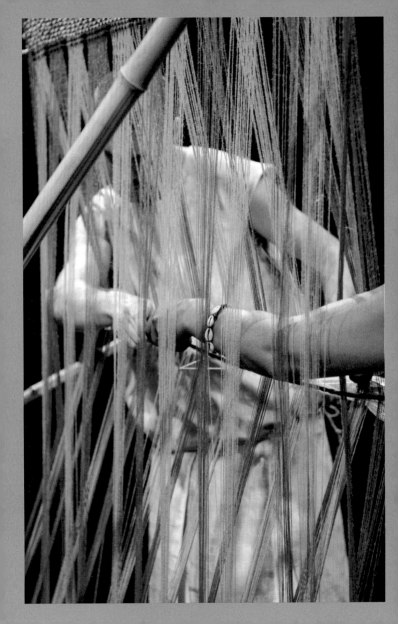

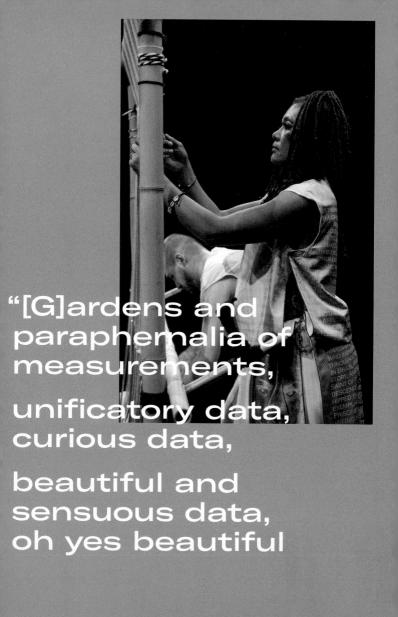

"[G]ardens and
paraphernalia of
measurements,

unificatory data,
curious data,

beautiful and
sensuous data,
oh yes beautiful

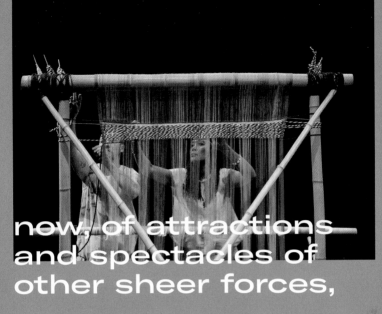

now, of attractions
and spectacles of
other sheer forces,

and types in the
universe, the
necessary

exotic
measurements,
rarest, rarest
measuring tapes

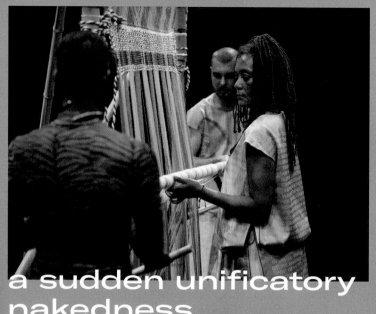

a sudden unificatory
nakedness,
bificatory
nakedness,

of numbers,
of violent fantasms

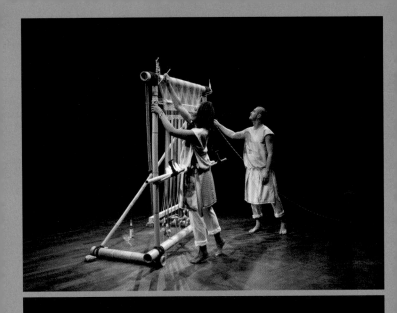

this serendipity
of calculators,
of footprints..."

An Annotated Bibliography

The Thread and the Gap (2019)* is a performance that
mobilizes the poetics of sound, text, textiles, and bodies
in order to create a site for encountering the "colonial
gap." Using a handmade loom, Kaersenhout and Likavčan
weave a textile while inviting members of the audience
to join them. An audio recording of the poem "Ossuary I"
by Dionne Brand is read by writer and performer Pelumi
Adejumo (first published in *Ossuaries* [New York:
Random House, 2010]). Two excerpts from the poem
accompany this visual essay. What follows is an annotated
bibliography composed of the conceptual threads that
informed encounters and conversations that led to the
performance.

Colonial Gap

Walter Mignolo and Rolando Vázquez, "Decolonial AestheSis: Colonial Wounds/
Decolonial Healings," *Social Text Online*, 15 July 2013, https://socialtextjournal.org/
periscope_article/decolonial-aesthesis-colonial-woundsdecolonial-healings/.

The epistemic erasure inherent to coloniality produces
what one might call the colonial gap. This gap is created by
the colonial powers of capture and consumption that claim
control over the imagination of the world as a whole. *We
have lost whole worlds*—worlds that are not only materially
suppressed but also effectively silenced; cultures that are
completely disregarded as places of knowledge and as
places of thought that can question the contemporary.

Coloniality and Archive

Walter Mignolo, *The Darker Side of Western Modernity* (Durham, NC: Duke
University Press, 2011).

One of the most poignant inscriptions of the colonial
gap is the *archive*; the site of categorial segmentation of
the past. The violence of the archive lies in what it does
not account for: the all-too-visible crimes and nameless

victims of coloniality. Not only whole worlds are lost here, but whole lives—the lives of ancestors that might be constitutive of their inheritors. The lack of a genealogy generates a vacuum of knowledge—the toxic condition that perpetuates the colonial gap in contemporary racial injustices.

The (Im)possibility of an Ethical Life

Rolando Vázquez, "Precedence, Earth and the Anthropocene: Decolonizing Design," *Design Philosophy Papers*, vol. 15, no. 1 (2017).

In light of this condition, do we in the west face the impossibility of living an ethical life? And if so, is there any way to develop out of this condition, toward new cultural techniques of being together that acknowledge the plural ecology of thinking and doing that makes us who we are?

Cosmograms

John Tresch, "Cosmogram," in *Cosmograms*, Melik Ohanian and Jean-Christophe Royoux, eds. (Berlin: Sternberg, 2005).

Weaving is an old metaphor for the material inscription of abstract, mathematical knowledge of the real. In this sense, textiles are turned into small-scale *cosmograms*: visual embodiments of patterns that represent larger relations in the universe. To weave is to count: a mathematics of the body, not of the mind. The textile becomes an index of intuitive knowledge, repeating the ways we are woven into the life of things.

Critical Fabulation

Saidiya Hartman, "Venus in Two Acts," *Small Axe: a Caribbean Journal of Criticism*, vol. 12, no. 2 (2008), pp. 1–14.

The woven cosmogram contains a gesture that goes beyond the act of synthesis, beyond unification—which would be just a covert imposition of one symbolic order over another. There is something non-hierarchical in the

way the pattern on the textile grows with its surface, as if the image were its own floor. The medium narrates itself, operating without representing, an exercise in critical fabulation.

A Post-Ethical Condition

Friedrich Nietzsche, "On Truth and Lie in an Extra-Moral Sense," *The Portable Nietzsche*, ed. Walter Kaufman (London: Penguin, 1976).

Perhaps the power of this weaving together, with all its counterintuitive aspects, offers a site of mutuality that points toward a post-ethical condition in which coloniality is recognized as fundamental to the history of our contemporary selves, but held in subsumption, thus overcoming the impossibility of being together in our cosmograms of plural ecologies of being.

The Thread and the Gap, a performance by Patricia Kaersenhout and Lukáš Likavčan, took place on 22 June 2019 at BAK, basis voor actuele kunst, Utrecht in the context of *Propositions #8: I Wanna Be Adored (the Non-Fascist remix)*. It was the culmination of the BAK 2018/2019 Research Fellowship post-academic program with performance, music, installations, hosted space, dancing, bites, and celebration. Photos: Tom Janssen

Abdicating Sovereignty

Sven Lütticken

Post-Westphalian Neofascism

Much contemporary neofascist rhetoric revolves around the trope of sovereignty. This is usually meant as national sovereignty. In the Brexit campaign, politicians like Nigel Farage and Jacob Rees-Mogg promised a restoration of British sovereignty, and an exit from European "vassalage." Trump, for his part, told the United Nations: "I honor the right of every nation in this room to pursue its own customs, beliefs, and traditions. The United States will not tell you how to live or work or worship. We only ask that you honor our sovereignty in return."[1] But where does sovereignty really lie in the "sovereign nation states," whose principles are often viewed as having been enshrined in the 1648 Peace of Westphalia? This so-called Westphalian system of sovereign states, that each have their allotted territory, has met with significant historical and theoretical interest in recent years, precisely because it has been eroding.[2]

During the nineteenth century, the nation-state was infused with reactionary, romantic ideas of the organic and unified *Volk* (people) as its bio-cultural basis, which reached its violent apogee in the early twentieth century. In (West) Germany after World War II, the reaction to this historical disaster was twofold: on the one hand, it became a dogma of representative democracy that *das Volk ist der Souverän* (the people are sovereign) and, on the other, European unification and international cooperation became imperative. Today, it is not only fascists defining the *Volk* in racial terms who feel that the latter made a mockery of the former. International cooperation and European integration moved in sync with neoliberal globalization, which gutted social welfare programs while moving production offshore; advances in transportation and communication technology, coupled with new "financial products," turned nation-states into local franchises

of transnational capital. Meanwhile, as China strengthens its "great firewall" to achieve "data sovereignty," European integration and neoliberal globalization have fostered discontent with national parliamentary politics, even while these "populist" or neofascist tendencies are fanned by members of the elite, often with Wall Street ties, from Trump's Goldman Sachs boys to Rees-Mogg among the Brexiteers and Alice Weidel in the Alternative for Germany party.

Even with the rise of the notion of "popular sovereignty," which has been a mantra since the US-American and French revolutions of the late eighteenth century, sovereignty has always been open to personification. Are sovereign states ruled by sovereign peoples? Are the people not themselves in need of a strong leader, a true sovereign? This was Thomas Hobbes's contention in *Leviathan* (1651): arguing that to escape from a violent and lawless state of nature, people must form a covenant and institute a state, necessarily involving the delegation of power to a sovereign—which could be some sort of committee, but ideally a single monarch. Not having read the terms and conditions, Hobbes's people are shackled to this monarch for life. The king is their representative, but not in the manner of parliamentary democracy. In an impressively counterintuitive theory of sovereignty, Hobbes argues that the representative or "actor" has virtually limitless freedom and no obligations once he has been designed by an "author."[3] This, then, is a reactionary theory of representation that bypasses all control mechanisms.

Today's neofascist strongmen (those would-be "strong men") cast themselves in the role of the truer representative, channeling the will of the (white, especially male) *Volk* in a more authentic way than parliaments and "professional politicians." Indeed, these populists seek to portray

and embody a certain vision of "the people" over a more technocratic and procedural notion of delegation.[4] If the Hobbesian sovereign had the power to suspend the law, to decide on the exception, then it is only consequential that the current redefinition of popular sovereignty often goes hand in hand with a partial suspension of rights: one only needs to think of the stripping of citizenship, which is increasingly used for terror suspects (who are never white) in the United Kingdom and elsewhere, and which—like the Windrush scandal—sends the message to immigrants that their citizenship is always on parole.[5]

In the 1930s, Georges Bataille characterized fascism as a return to "the Sovereign Form of Sovereignty," noting that it "makes an appeal to sentiments traditionally defined as exalted and noble and tends to constitute authority as an unconditional principle, situated above any utilitarian judgment."[6] For Bataille, planning and constructing the future through work—whether under capitalism or in Stalinist Communism—results in people's enslavement to a linear and teleological temporality. "What is sovereign in fact is to enjoy the present time without having anything else in view but this present time."[7] The modern western subject is always focused on a future that is to be conquered (more production, more accumulation); the sovereign is not. Seeking to counter fascism's restoration of sovereign mastery, of hierarchy and power over life and death, Bataille first sought to create a "horizontal" secret society in which hierarchic leadership would be replaced by "headlessness": a non-fascist restoration of sovereignty in a cultic context.[8] In a later text, from the 1950s, he would note that "the question of sovereignty is usually poorly formulated; in particular, it is poorly formulated if we confuse it with the autonomous decision of an individual." If an "autonomous decision" does not "[go] beyond what is useful, [it] may have no sovereign quality at all; it

may even be servile; it may show the subservience of the one who freely made it."[9]

While Bataille's notion of the negation of utility opposes the reduction of life to toil and survival, it provides no perspective for the transformation of society, only for the momentary restoration of lost heterogeneity and intimacy. Furthermore, Bataille's reduction of autonomy to a kind of purposive rationality would not have sat well with the Frankfurt School, which analyzed precisely the mutilation of true autonomy—human self-determination—under advanced capitalism.[10] It is precisely the stinted sub-jectivity of subjects unable to develop into autonomous human beings that made the triumph of fascism possible. By the 1960s and 1970s, theorists and activists in Italy in particular would advocate and practice forms of collective autonomy. Coming out of Workerism, this take on auton-omy could not be further from the neoliberal ideologi-zation of the autarkic, entrepreneurial self. Liberation from neoliberal notions of autonomy and from neofascist versions of sovereignty must also entail the defense of emancipatory versions of both concepts.

Two Sovereignties

From the mid-1980s into the late 1990s, cyberpunk novelists and theorists linked to the burgeoning hacker scene started imagining and conceptualizing a breakdown of traditional national sovereignty due to the rise of the Internet. The notion of the data haven—a tax haven for data beyond the reach of major nation-states—features in certain William Gibson novels and, very centrally, in author Bruce Sterling's *Islands in the Net* (1988), which paints the picture of a world largely controlled by transna-tional corporations who find their dialectical counterpart in island strongholds such as Granada, run as data havens by postcolonial buccaneers.[11] Another novel centered

around the data haven concept, Neal Stephenson's *Cryptonomicon* (1999), became a reference point for Daniel van der Velden and Vinca Kruk, who in 2004–2005 constituted themselves as the design and theory collective Metahaven.[12] In their early work, they investigated the crisis and transformation of territorial sovereignty by devising new visual identities for the North Sea data haven Sealand, "city states," and WikiLeaks—the latter, of course, the seeming apogee of the hacktivist assault on the nation-state, before Julian Assange revealed his closeness to a certain neo-autocracy. Unfortunately, Metahaven has also largely abandoned their interventionist use of graphic design and branding while restyling themselves as filmmakers—which has resulted in an increasingly dismal series of films and video installations that blend a kitsch-ified, sub-Tarkovskyan aesthetic with voice-over snippets by memefied theorists. Metahaven's airport or freeport art has itself become little more than a dismal symptom of actually existing globalization.[13]

Perhaps the most illuminating piece of speculation to come out of the period marked by Net theory and cyberfiction is James Dale Davidson and Lord William Rees-Mogg's *The Sovereign Individual* (1997). The authors were the publishers of *Strategic Investment* newsletter, and their book is a hymn to a transnational or postnational *über*-class to come: "the nation-state will be replaced by new forms of sovereignty, some of them unique in history, some more reminiscent of the city-states and medieval merchant republics of the premodern world."[14] Citing Stephenson's fictional cyberspace, the "Metaverse," the authors predict that increases in bandwidth will soon make possible such communities whose "participants will seek and obtain exemption from the anachronistic laws of nation-states."[15] However, in an act of defiant anachronism, Davidson and Rees-Mogg look to the

feudal Middle Ages and their complex geopolitical quilt of sovereignties as a possible role model. Presaging that "individuals will achieve increasing autonomy over territorial nation-states through market mechanisms," Davidson and Rees-Mogg foresee the emergence of "merchant republics of cyberspace."[16]

If the Hobbesian sovereign could, in philosopher Joseph Vogl's analysis, declare himself sovereign by virtue of his status as universal creditor, himself indebted to no one, then the rise of public debt undermines sovereignty. "The cycle of public borrowing and private credit was already seen as a ruinous exception to the exceptionality of sovereign power in the early modern period," and today finance and debt again wreak havoc on a conception of sovereignty as embodied by the nation-state.[17] The perfect neofascist is someone who, like Trump, acts like a lord of chaos in a Bakhtinian carnival, selling his undermining of institutions of governance as a reclaiming of "our" sovereign power from elites, all the while slashing rules and regulations in the service of finance capital—the true autonomous subject—and its sovereign servants among the one per cent.[18]

Davidson and Rees-Mogg's treatise embodies the kind of Silicon Valley ideology that Trump's backer Peter Thiel would take to great heights. That Thiel is obsessed with attaining sovereignty vis-à-vis the nation-state, for instance via "seasteading," did not, of course, prevent him from supporting Trump, who promises to restore national sovereignty and "make America great again"—just as Rees-Mogg's son Jacob campaigned for Brexit while the company he co-owns (Somerset Capital Management) set up an investment fund in Ireland.[19] This is the double promise of sovereignty: the one per cent get one kind, the rest get national sovereignty—and, more particularly, the

promise of a kind of national sovereignty in which many are classified as non-humans, and whose classification wars can put even poor whites in a position of mastery.

Today's autonomous assholes on Twitter and sovereign little shits on message-boards are the farcical but no less toxic and dangerous outcome of a dismal history. When interviewing the cognitive psychologist Stephan Lewandowsky, artist Wolfgang Tillmans was shocked to hear that young people now (in contrast to 40 years ago) are above all interested in "leadership and making money," people are "less trusting generally to each other," and often have only one friend: "in America a vast proportion of people is one person away from total social isolation."[20] As if in response, artist Adrian Piper's series of works *Probable Trust Registry: The Rules of the Game #1–3* (2013–2017) presents a series of quasi-contractual documents for establishing trust on the basis of statements such as "I will always mean what I say" and "I will always be too expensive to buy," thus aiming to strengthen the character traits needed for trust and collaboration.[21] Social theorist and artist Bini Adamczak has questioned the historical tendency of revolutionaries to focus on ideas, theories, manifestos, and programs rather than on the relational forms (the *Beziehungsweisen*) of councils, communes, commons, or associations. If capitalism rests on private property and on the self-reliant legal person (historically white, male, and wealthy, even though now to some extent "democ-ratized") as the juridical subject that can own and sell property, then the question is, Adamczak contends, what could play a comparable role under communism: What kind of *Beziehungsweise* not grounded on private prop-erty are possible, and how to develop and strengthen them?[22]

The sovereign individual must abdicate, just as the autonomous subject must take his hat. This will no doubt be a slow and painful progress, with two forward steps being followed by one step back—or the reverse. What is crucial for this process is the elaboration and practice of a different understanding of both autonomy and sovereignty. Autonomist feminists have long insisted that autonomy needs to be understood not in terms of a delusional autarky, but as the ability to choose one's dependencies.[23] And would sovereignty not be precisely the inexplicable and unreasonable refusal to become a useful pawn, not coalescing into a data double to be targeted by Cambridge Analytica or similar outfits; enjoying a present time that is not that of a Pavlovian dog responding to the stimuli provided by bots and trolls?

Everything Else Has Failed

In Jean-Luc Godard's 2001 film *Éloge de l'amour* (In Praise of Love), a character reads from Bataille's posthumous fragment *L'amour d'un être mortel*: "*Rien n'est plus contraire à l'image de l'être aimé que celle de l'état.*"(Nothing is more contrary to the image of the loved one than that of the state).[24] Here we again have Bataille's contrast between the (instrumental, power-driven, territorializing) sovereignty of the state and the (excessive, wasteful, deterritorializing) sovereignty of love. Godard's film can be placed in a tangled genealogy of recent artistic and theoretical re-engagements with love; its title was later echoed by Alain Badiou.[25] If this may seem like a leap into a somewhat frivolous niche of contemporary immaterial labor, I would argue that the resurgence of interest in love, and affect in general, presents a valid and urgent practico-speculative response to the unfolding catastrophe of neoliberal capitalism and its dialectical flip into neofascism.

In a 2007 performance taking the form of a single-person public "protest," artist Sharon Hayes noted with a tone of existential despair: *Everything Else Has Failed! Don't You Think It's Time For Love?* The unspecified "you" addressed by Hayes acts as a linguistic and social shifter; it could be anyone, even a multitude. Her 2008 demonstration piece at the Republican National Convention, *Revolutionary Love: I Am Your Worst Fear, I Am Your Best Fantasy,* appropriated a historical Christopher Street Day slogan, collectivizing and politicizing what to Republican evangelicals should remain "forbidden love." Beyond this, Hayes's work evinces a fundamental interest in protest movements and modes of grassroots organizing, recalling the Invisible Committee dictum: "Organizing ourselves has never been anything else than loving each other."[26] But neoliberal modes of sociability and survival also depend on a weaponization of affect. In an essay that was partly reused by Metahaven for their video *City Rising* (2014), writer Brian Kuan Wood has characterized love under post-Fordism as not "an elevated romantic phenomenon but the economization of empathy. Love is immaterial capital in the absolute in a sphere of value relations where capital and labor are no longer the main operators or arbiters of value."[27]

> [When] Thatcher proclaimed there was no such thing as society, that there are only people, she was making an argument for true love—not the state-sub-sidized universal love driven by some ethical idea of equality. Families and friends, a true conservative love. But to return to Lacan's formulation, when the stakes are lowered even further—say, following Thatcher—there is very little to be given or received other than affection and emotional support, prom-ises and white lies, and maybe even some personal ethics to hold it all together in the meantime.[28]

Just as neoliberal subjects plan their future love life with military precision—like a merger between two successful ego-corporations, plotting ahead to ditch a partner who may be "boyfriend material" but not "husband material" in favor of someone to settle down with and raise privileged children—so "revolutionary love" is marked in manifold ways by the order it rejects.[29]

In matters of love, the terrain and terminology are slippery. One fundamental distinction in western thought has been that between Eros (sensual love) and Agape (Christian charity). When Hegel declared that, after the collapse of the Pantheon of ancient Gods and the advent of Christianity, the content of art was henceforth love, he was very much thinking in terms of Agape. When God incarnated in Christ it was a gift of love, a reconciliation of spirit with matter, and the inauguration of a world of "spiritual beauty" and freedom. In fact, the freedom ideologized by Hegel was severely qualified. German Romantic Friedrich Schlegel's *Lucinde* (1799), with its celebration of Eros and unwed free love, was attacked by Hegel in the starkest terms. Schlegel's celebration of romantic love as a way of "romanticizing the world" via the loved one could only be seen by Hegel in terms of "moral depravity."[30]

Encompassing the many shades of Eros and Agape, the *Army of Love* project, initiated by writer and artist Ingo Niermann and developed by him with artist Dora García, started out as a book and a video by Niermann on an "army" that would spread sexual *jouissance* to those who do not count as successful "sovereign individuals."[31] Niermann's performative fiction resolves around people who "believe that only when the redistribution of material wealth includes equal chances of finding sex and love—no matter how elderly, disabled, or ugly you are—communism will become real." García and Niermann started organizing workshops

or training camps in order to sound out the conditions for a commons of desire and affect (which of course can only be based in consent, not on conscription, and which may have many degrees and forms of enlistment).

Again, an *Army of Love* producing workshops and videos may seem frivolous in the face of neofascism. The fact that the activities are usually hosted by art spaces means that there is an obvious discrepancy between the utopia outlined by Niermann and the practice. While the artists and their host institutions try to involve other organizations, groups, and networks, the Army's workshops are hardly balanced in terms of the participants' age, race, gender, level of education, and access to culture. This invalidates neither the utopia nor the practice; any propositional project will be partial and problematic. This is not an excuse for acceptance of endemic and systemic social divisions and separations; it *is* an incentive to continue working under and against imperfect and worsening conditions. The paradox is that what we urgently need is patient and painstakingly slow work on (inter-/trans-) subjectivity. We need to start all over again, working with the human and social wreckage that we are part of. We need to dis- and reassemble. Everything else has failed.

1: "Remarks by President Trump to the 73rd Session of the United Nations General Assembly/New York, NY," New York, 25 September 2018, https://www.whitehouse.gov/briefings-statements/remarks-president-trump-73rd-session-united-nations-general-assembly-new-york-ny/.

2: For a critical reappraisal of the Westphalian system as a myth, particularly in light of later and arguably more crucial developments (the Napoleonic Wars and nineteenth-century conceptions of sovereignty), see Andreas Osiander, "Sovereignty, International Relations, and the Westphalian Myth," *International Organization* 55, no. 2 (Spring 2001), pp. 251–287; and Stéphane Baulac, "The Westphalian Model in Defining International Law: Challenging the Myth," *Australian Journal of Legal History* 8, no. 2 (2004), http://

classic.austlii.edu.au/au/journals/AJLH/2004/9.html. Much of the recent "Westphalianism" in certain contemporary para-academic circles is due to Benjamin H. Bratton, *The Stack: On Software and Sovereignty* (Cambridge MA: MIT Press, 2015), which boasts a Metahaven-designed cover.

3: Thomas Hobbes, *Leviathan* (London: Penguin Classics, 1981), pp. 217–222. See also Hanna Fenichel Pitkin, *The Concept of Representation* (Berkeley, CA: University of California Press, 1967), pp. 14–37.

4: Gayatri Chakravorty Spivak, "Can the Subaltern Speak?," in *Colonial Discourse and Post-Colonial Theory: A Reader*, Laura Chrisman and Patrick Williams, eds. (New York: Harvester Wheatsheaf, 1993), pp. 70–72.

5: Nesrine Malik, "Stripping Criminals of their UK Passports—Even Terrorists and Sex Abusers—Is Dangerous," *Guardian*, 1 March 2016, https://www.theguardian.com/commentisfree/2016/mar/01/stripping-criminals-uk-citizenship-racisrt-sex-abusers-terrorists-two-classes-citizens. The home secretary at the time was Theresa May, who was also in charge of the Windrush dossier, before becoming a famously "strong and stable" prime minister.

6: Georges Bataille, "The Psychological Structure of Fascism," in *Visions of Excess: Selected Writings, 1927–1939*, trans. Allan Stoeckl, et al. (Minneapolis, MN: University of Minnesota Press, 1985), p. 153. The closest historical analog for fascism's dramatic rise, Bataille avers, was the rise of "the Islamic Khalifat": "Just like early Islam, fascism represents the constitution of a total heterogeneous power whose manifest origin is to be found in the prevailing effervescence." This casting of Islam as the Absolute Other was later taken up from a far-right perspective by Bataille's erstwhile associate Jules Monnerot, who during the 1980s moved into the orbit of the Front National party. The Front National, of course, stands for the post- and neofascist reaction to European integration and globalization—or for the exploitation of the discontent generated by deterritorialization.

7: Georges Bataille, "Sovereignty," in *The Accursed Share: An Essay on General Economy. Volumes II and III*, trans. Robert Hurley (New York: Zone Books, 1991), p. 197.

8: *Acéphale* was also the name of a journal published from 1936 to 1939, which can be seen as the (semi-)public counterpart of the secret society.

9: Bataille, "Sovereignty," p. 311.

10: An early example of this analysis is Herbert Marcuse, *A Study on Authority* (1936), trans. Joris de Bres (London: Verso Books, 2008). Here, Marcuse

reflects on a tendency in bourgeois thought that he traces from Luther to Kant and beyond, a "union of internal autonomy and external heteronomy."

11: Bruce Sterling, *Islands in the Net* (New York: William Morrow/Arbor House, 1988).

12: See the two models of Sealand using Stephenson's *Cryptonomicon* and Negri and Hardt's *Empire*, in Metahaven, *Uncorporate Identity* (Baden: Lars Müller Publishers, 2010), pp. 68, 84–85. Other such models use More's *Utopia* and Deleuze and Guattari's *A Thousand Plateaus*. The name Metahaven could also be seen as evoking Stephenson's concept of the cyberspace "Metaverse" from his novel *Snow Crash* (1992).

13: Or, as Ana Teixeira Pinto puts it: "precariousness [or the 'planetary instability' of our collapsing world order] is not challenged politically; rather, it is rendered lurid and recuperated into a libidinal economy." Ana Teixeira Pinto, "Tuned to an Undead Channel," in *PSYOP: An Anthology*, Metahaven and Karen Archey, eds. (Amsterdam: Stedelijk Museum, 2018), p. 75.

14: James Dale Davidson and Lord William Rees-Mogg, *The Sovereign Individual: Mastering the Transition to the Information Age* (New York: Simon & Shuster/Touchstone, 1997), p. 99.

15: Davidson and Rees-Mogg, *The Sovereign Individual*, p. 30.

16: Ibid., p. 32.

17: Joseph Vogl, "The Ascendancy of Finance," *Artforum* 55, no. 10 (Summer 2017), p. 332.

18: Florian Cramer, "Weaponization of the carnivalesque: Breaking Down 'Alt-Right' Meme Culture," (lecture, Netherlands Institute for Cultural Analysis, Amsterdam, 20 April 2018).

19: Lizzy Buchan, "Brexit: Jacob Rees-Mogg Defends Ireland Move by City Firm He Co-founded Ahead of EU Withdrawal," *Independent*, 14 June 2018, https://www.independent.co.uk/news/uk/politics/brexit-jacob-rees-mogg-scm-ireland-city-move-eu-withdrawal-dublin-a8398041.html.

20: Wolfgang Tillmans, "Interview with Stephan Lewandowski," in *What Is Different? Jahresring 64*, Brigitte Oetker and Wolfgang Tillmans, eds. (Berlin: Sternberg Press, 2018), p. 24.

21: Adrian Piper, *The Probable Trust Registry: The Rules of the Game #1–3*, Hamburger Bahnhof—Museum für Gegenwart, Berlin, 24 February–3 September 2017, https://www.smb.museum/en/exhibitions/detail/adrian-piper-the-probable-trust-registry-the-rules-of-the-game-1-3.html.

22: Bini Adamczak, *Beziehungsweise Revolution. 1917, 1968 und kommende* (Berlin: Suhrkamp, 2017), p. 76.

23: A version of this statement is quoted by Adamczak as "*Autonomie ist selbstbestimmte Abhängigkeit,*" in ibid., p. 99. For a different version, inspired by a remark of Vivian Ziherl, see my "Neither Autocracy nor Automatism: Notes on Autonomy and the Aesthetic," in *Cultural Revolution: Aesthetic Practice After Autonomy* (Berlin: Sternberg Press, 2017), p. 65.

24: See also Jean-Luc Godard, *Éloge de l'amour. Phrases (sorties d'un film)* (Paris: P.O.L., 2001), p. 36.

25: Alain Badiou and Nicolas Truon, *In Praise of Love* (New York: New Press, 2012).

26: The Invisible Committee, *Now*, trans. Robert Hurley (South Pasadena: Semiotext[e], 2017), p. 29.

27: Brian Kuan Wood, "Is It Love?," *e-flux journal*, no. 53 (March 2014), https://www.e-flux.com/journal/53/59897/is-it-love/.

28: Ibid. Intriguingly, slipping into the language of imperial sovereignty, Wood also rhapsodizes about the coming of a "tyrant called love."

29: My example of economizing calculation in matters of the heart is drawn from life: a conversation between a couple of (female) students at my university overheard by my colleague Kerstin Stakemeier, who reported it to me with great indignation.

30: G.W.F. Hegel, *Vorlesungen über die Ästhetik II. Werke 14* (Frankfurt am Main: Suhrkamp, 1986), pp. 154–159.

31: Connal Parsley, "'A Particular Fetishism': Love, Law, and the Image in Agamben," in *Giorgio Agamben: Legal, Political and Philosophical Perspectives*, Tom Frost, ed. (Abingdon: Routledge, 2013), p. 33.

Scarecrows

Jumana Manna

My parents and extended family regularly forage wild plants for food and medicine, like many Palestinians and Syrians before them.

A multitude of edible plants grow throughout the hilly landscape of historic Palestine and the occupied Golan Heights. Sustenance practices like seasonal foraging predate the rhythms of agricultural cultivation and the state imposition of commercial and sovereign interests. In 1977, Israel's then Minister of Agriculture, Ariel Sharon declared *za'atar* (Arabic for thyme or *Majorana syriaca*) a protected species, resulting in a de facto criminalization of those who collect it in the wild. Nearly three decades later, *'akoub* (*Gundelia tournefortii*), a thistle-like plant largely unknown to Israelis but essential to northern Palestinian cuisine, was also added to the list of protected plants. These listings effectively placed a total ban on the tradition of collecting edible vegetation, making it punishable by fines and up to three years in prison.

For the Palestinians and Syrians in the Golan, these preservation laws constitute a thin ecological veil for racist legislation designed to further alienate them from their lands. Lands that, in many cases, have been expropriated by the Israeli state and are administered as Israeli settlements, nature reserves, military training areas, and other forms of "state land."

In line with colonial logic, the state has endowed itself with the expertise and the moral high ground over the purported destructive tendencies of the Arabs, opting to criminalize foraging rather than settle for less oppressive measures. In this contested landscape, the continued collection of *'akoub* and *za'atar* in the wild, despite and in spite of the ban, becomes an act of anti-colonial resistance and a bid to hold on to memory and know-how that is fast eroding.

These photographs were taken while shooting a film about foraging in Palestine, a film that is still in its early phases but that is ultimately concerned with questions of what is made extinct and what gets to live on; about who gets to decide the fate of these foraging traditions and the options that remain for those who don't.

The hills of the occupied Golan Heights facing the Sea of Galilee are filled with many edible wild plants, as well as land mines. Since its occupation in 1967, Israel has left much of the Golan uncleared of mines. The yellow flowering plant most prominently visible in this image, *kalech* (*Ferula scorodosma*), from the mustard seed family, is plentiful in this area, as is the much sought-after *'akoub*. The *kalech* buds, though edible before they flower, become poisonous once blooming. My late grandmother claimed that this bud could cause dizziness if not cooked thoroughly. Goats know not to eat the flower, but sheep frequently ingest them, causing problems for shepherds and their flocks.

Zeidan on a foraging trip in
the Upper Galilee with his six
dogs, Dun-dun, Ma'mouleh,
Kharoubeh, Fada'r, Kishko, and
Khash-khasheh.

An Israeli Nature and Parks Authority vehicle on one of their routine lookouts for illegal activities.

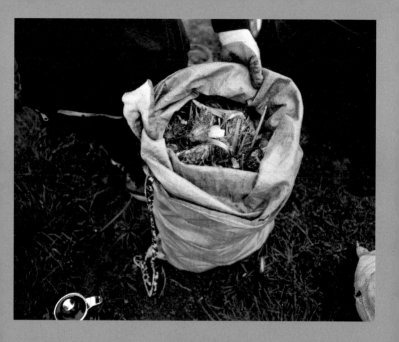

A sack full of foraged 'akoub in the Golan Heights. This quantity can take up to two hours for one person to collect. Once the thorns are cleaned, it will make a meal for a small family.

Olive tree trunk near a patch
of wild *za'atar*. Outskirts of
Jerusalem.

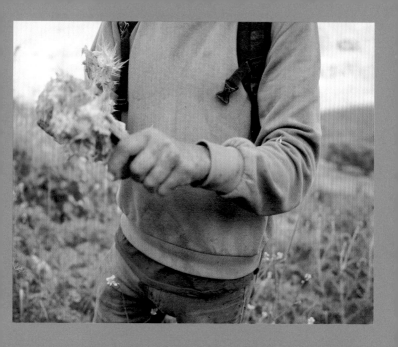

'*Akoub* foraging in the Upper
Galilee and Golan Heights.
The plant is clipped at its base,
slightly below soil-level, and the
thorny leaves stripped away to
reach the edible heart.

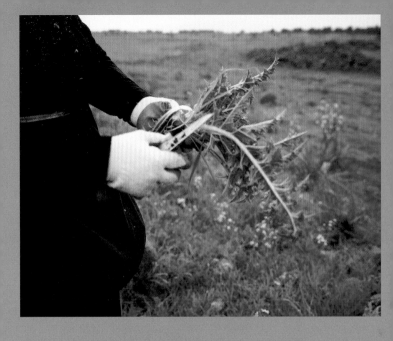

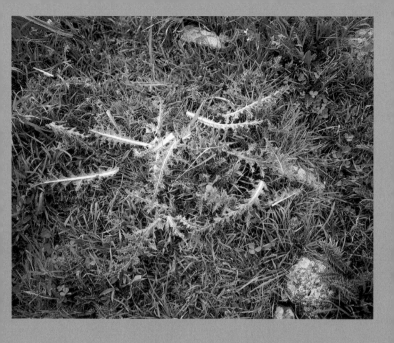

A forager's leftovers:
thorny *'akoub* leaves.

The Palestinian village of Suba was destroyed in July 1948 by the Palmach (the Jewish paramilitary force during the British Mandate of Palestine, later assimilated into the Israel Defense Forces) and established soon after as what is now known as Tzova, a kibbutz on the outskirts of Jerusalem. The undeveloped areas, including parts of the old village, are filled with many kinds of edible plants and fruit trees, making Suba a regular foraging spot for my parents.

Fertility idols on display in the contested *Finds Gone Astray* exhibition, Bible Lands Museum Jerusalem, Jerusalem. Featuring a selection of ancient regional artifacts confiscated from "illegal looters" in the West Bank by Israeli authorities, the exhibition reproduces a longstanding narrative that Jewish-Israelis protect the land and its past, while Arabs destroy it.

Alien-faced scarecrow at the
entrance of the Abu Jabal
family's apple tree groves,
Golan Heights.

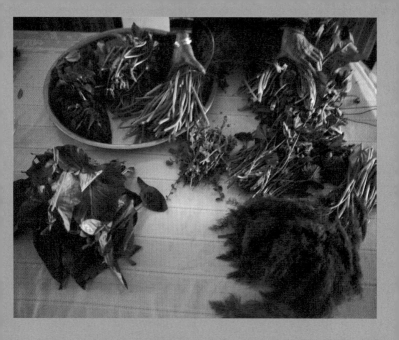

My mother sorting her foraged food. Including *khubeizeh* (mallow, *Malva parviflora*); *shomar* (fennel, *Foeniculum vulgare*); *za'atar*, (wild za'atar, *Majorana syriaca*); *'elt*, or *hindbeh* (dandelion, *Taraxacum officinale*); *hummeid* (bitter dock, *Rumex obtusifolius*); *loof* (black calla, *Arum palaestinum*); and *wara' zquqiah* or *Tutu* (ivy-leaved cyclamen, *Cyclamen hederifolium*).

Non-Fascist AI

Dan McQuillan

Does AI have a politics?

When discussing propositions for a non-fascist artificial intelligence (AI), we should first ask whether AI has a politics at all. AI, as it really exists, is simply machine learning and neural networks,[1] not posthuman intelligence with its own agenda. But there are authoritarian tendencies associated with AI, that arise from the resonance between its concrete operations and the surrounding political conditions. We have reason to worry not only about the uses to which AI might be put, but also about the inherent characteristics of the technology itself. To make these characteristics visible, so they can be overcome, requires some appreciation of the actual workings of AI.

Machine learning and neural networks are forms of computational pattern-finding. Their uncanny ability to recognize faces or play Go doesn't come from a spark of consciousness in the circuitry, but from vast calculations of probabilities. To render a real-world situation amenable to AI means abstracting numerical features and running many examples through iterative calculations involving an objective function. The objective function defines some abstract mathematical distance between the model's current classification of the pattern and the correct one, and strives to minimize or optimize that distance. What makes this operation powerful is the convergence of computational methods such as backpropagation,[2] the vast seas of data that are now available, and the development of microprocessors called graphics processing units (GPU) that can handle the necessary scale of parallel calculations.

The result is a giant leap in the abilities of automated systems. They can recognize faces as well as we can, so perhaps they can perform cancer scans with the same kind of accuracy. And what about law enforcement?

Judges deciding bail already review a suspect's criminal record and associations; perhaps, if we expand the data involved and run it through AI, we can discern a more reliably predictive pattern. And here is the first problem: for a culture steeped in faith in scientific authority, empirical calculations are taken to reveal something more significant about the world than mere experience. Never mind that these patterns are correlations rather than some determination of causality. The engineering solutionism that defines Silicon Valley sees no limit to the application of AI in messy social contexts, so it can draw out insights that were previously obscured by unreliable and subjective discourse.

AI's character as a form of probabilistic prediction leads inevitably to preemption: kinds of intervention intended to change the course of events. This has a particular appeal in a time of austerity and financial crisis. AI's targeting is seen as a way to square the circle between cash-strapped services and rising demand—and for corporations to keep squeezing a result out of falling profit rates. Under neoliberal logic, the best result comes from the sum of signals in a free market, while the objective functions of AI make predictions by summing vectors over troves of training data. Thus, the optimizations of AI extend neo-liberal logic into the near future. Decisions to allocate or withdraw resources become algorithmic means by which to bring the future into the present. AI provides a general-izable, technocratic method for reducing profound social questions to optimization problems. Like bureaucracy in the twentieth century, AI is poised to become the unifying logic of legitimation across corporations and government.

Is AI fascist?
The computational classifications produced by AI are inserted into processes that previously entailed dialogue,

debate, and human judgment. They augment forms of governmentality through empirical speed and scale, while obscuring decisions that were previously understood to be political. This obfuscation is intensified when neural networks are involved, as they have an interpretability problem: the massively parallel and iterative calculations undertaken with neural networks can't be directly translated back into terms accessible to human reasoning. However, the risk posed by AI is not a machine-tyranny of automated decisions, but the amplification of existing human tendencies to automaticity. AI not only undermines due process, but produces thoughtlessness, in the sense that political philosopher Hannah Arendt meant when interpreting the actions of Nazi war criminal Adolf Eichmann: inability to critique instructions, lack of reflection on consequences, commitment to the belief that correct ordering is being carried out. These are forms of everyday fascist thinking, even when not undertaken on behalf of an explicitly far-right regime.

AI's predictions create new terrains of inclusion and exclusion with respect to resources and opportunities. By combining both judgment and intervention, the machinic classifications of AI will have the force of law without being of the law. According to philosopher Giorgio Agamben, this "force of" is the signature of states of exception, wherein rights and citizenship are suspended.3 The actions of everyday algorithms will not create a state of emergency per se, but constitute a continuous partial modulation of life chances. Whether the government is captured by far-right political movements or is simply appeasing them, the legal lacunae created by AI are ready to become the vectors for far-right policies. This was Agamben's point about the fascist states of the 1930s— they were not dictatorships but dual states with secondary structures that existed alongside the constitutional

ones. He warned that to which we need to be alert is not confusion of legislative and executive powers, but this separation of law and force of law.

But the overlap with far-right politics doesn't stop there. The character of "coming to know through AI" involves simplifications based on data innate to the analysis; and the reduction of social problems to matters of exclusion based on innate characteristics is precisely the politics of right-wing populism. We should ask whether the giant AI corporations would balk at putting the levers of mass correlation at the disposal of regimes seeking national rebirth through rationalized ethnocentrism. At the same time that French anarcho-communist Daniel Guerin was writing his book examining the ties between fascism and big business in 1936, Thomas Watson's IBM and its German subsidiary Dehomag were enthusiastically furnishing the Nazis with Hollerith punch-card technology. Now, we see the photos from Davos of Brazil's reactionary populist president Jair Bolsonaro seated at lunch between Apple's Tim Cook and Microsoft's Satya Nadella.

Meanwhile, the algorithmic correlations of genome-wide association studies are used to sustain notions of "race realism" and prop up the narrative of genomic hierarchy. This is a historical reunification of statistics and white supremacy, as the mathematics of logistic regression and correlation that are so central to machine learning were actually developed by Edwardian eugenicists Francis Galton and Karl Pearson. The risk of reductive optimization can be seen in the valorization of "general intelligence" by some of the most prominent AI practitioners. This occurs in the conflation of advances in AI as it actually exists, which is machine learning, and the belief this is a stepping stone to Artificial General Intelligence (AGI)—the transhuman intelligence of fictional AI. What

is notable in this context is not the weirdly religious belief in the coming of a higher intelligence, but the reductive identification of mind with intelligence and IQ. Popular amongst the elite "tech bros" of Silicon Valley, this form of human ranking on the basis of an intelligence metric is also the slide rule for so-called "race science," the pseudo-empirical justification of racial hierarchies that is the historical cornerstone of white supremacy.

How can we resist fascist AI?

We can't talk about a non-fascist AI without first considering how to resist the encroachments of AI that tend toward fascism. The well-meaning liberal position is to constrain the negative outcomes of AI in some way. Like AI itself, this has both "weak" and "strong" variants. The weak form is the hugely popular pastime of promoting AI ethics, which comes in 101 variations. This is already losing ground as it becomes clear that ethics is a PR exercise designed to calm public fears, while industry gets on with unrestrained implementation. The strong form of liberal restraint is to compel fairness through law, that is, to address AI's production of imbalances in the same way as legislation against other discriminations. However, this imagines that society is already an even playing field, and obfuscates the structural asymmetries generating the perfectly legal injustices we see deepening every day. It's exactly these that will be amplified by algorithmic systems.

The predictive pattern recognition of deep learning is being brought to bear on our lives with the granular resolution of Lidar. Either we will be ordered by it, or we will organize. So, the question of a non-fascist AI is the question of self-organization, and of the collective production of the self and community that comes about through organizing. There are already signs of resistance

in the relations of production, such as the internal dissent at Google, Amazon, Microsoft, and so on, which contests the social purposes to which their algorithms are being put. To become really effective, the resistance to toxic applications needs to become part of a broader worker self-organization that can mobilize an alternative social vision. In the 1970s, workers in a United Kingdom arms factory came up with the Lucas Plan, which proposed the comprehensive restructuring of their workplace for socially-useful production.4 They not only questioned the purpose of the work, but did so by asserting the role of organized workers, which suggests that the current tech-worker dissent will become transformative when it begins attempting to create the possibility of a new society in the shell of the old.

The resistance to fascist AI becomes stronger at the point where worker dissent meets social movements. The breakthrough represented by current AI came with the huge leap in its ability to recognize faces, as signaled by the results of the 2012 ImageNet competition. Ironically, it may be that facial recognition is also the breakthrough point for social resistance. The engineers behind this form of facial recognition are themselves active in calling for constraints, while at the same time it has become a con-cern for social movements such as Black Lives Matter and broad coalitions of groups who are alarmed by the exten-sion of automated surveillance into their communities. Given the pace of AI's implementation across every aspect of social infrastructure, the struggle for self-determination in everyday life may require a new Luddite movement. New Luddites might look like the residents and parents in Chandler, Arizona, who blockaded Waymo's self-driving vans and threw rocks at them. "They didn't ask us if we wanted to be part of their beta test," said a mother whose child was nearly hit by one. The Luddites, remember, did

not oppose technology as such, but aimed "to put down all machinery hurtful to the Commonality."[5]

How do we achieve non-fascist AI?

A good start on the path to non-fascist AI is to take some guidance from feminist and decolonial technology studies that have cast doubt on our ironclad ideas about objectivity and neutrality. Standpoint theory suggests that positions of social and political disadvantage can become sites of analytical advantage, and that only partial and situated perspectives can be the source of a strongly objective vision.[6] Likewise, a feminist ethics of care takes relationality as fundamental; the effort to establish a relationship between the inquirer and their subjects of inquiry would help overcome the onlooker-consciousness of AI. The question is: How to mobilize situated knowl-edges and an ethics of care in and around the everyday practices of AI? In order to center marginal voices and relationality, I suggest that a non-fascist AI must involve some kind of people's council, to put the perspective of marginalized groups at the core of AI practice, and to transform machine learning into a form of critical pedagogy. This formation of AI would not simply rush into optimizing hyperparameters, but would question the origin of the problematics, that is, the structural forces that have constructed the problem and prioritized it.

The purpose of people's councils in non-fascist AI is also the overcoming of subjection. The dispersal of algorithmic systems across everyday life means they come to shape our habitus, that is, our ingrained habits, skills, and dispositions. They become exactly, as sociologist Pierre Bourdieu described, "structured structures predisposed to function as structuring structures."[7] Our relations with these systems of control affect how we know ourselves as subjects, our understanding of our place in society,

and our relationships with other people and institutions. The AI we don't want draws its influence as an overlay to the authoritarian and dualistic conditioning that already exists in society. Achieving a measure of self-realization and autonomy that is not based on individualism but on solidarity is a collective activity. A non-fascist AI is one that supports autonomy, and that supports freedom from the colonization of everyday life by the cultural codes of patriarchy, racism, or authoritarianism. In that way, it can only be a practice of people who are committed to autonomy; to the principle of refusing to be dominated, but also of refusing to dominate anyone else, by rejecting any participation in oppressive patterns of interaction. A people's council is a collective structure based on consensus, the equal voice of all participants, and grounded in the acknowledgement of all standpoints. Reaching decisions by consensus is the iterative process of finding positions to which everyone can commit.

AI is currently at the service of what philosopher Henri Bergson called ready-made problems; problems based on unexamined assumptions and institutional agendas, presupposing solutions constructed from the same conceptual asbestos.[8] To have agency is to re-invent the problem, to make something newly real, which thereby becomes possible. Unlike the probable, the possible is something unpredictable, not a rearrangement of existing facts. A non-fascist AI is one that takes sides with the possible against the probable. We need an AI that takes as its problematic exactly the sort of data features normally ignored for having no predictive value, because they represent shared conditions rather than individual idiosyncrasies. Rather than a technical exercise in the excision of risk, AI becomes a catalyst for more fundamental change and transformation. Asking, "how can we predict who will do X?," is asking the wrong question. We already know the

destructive consequences of poverty, racism, and systemic neglect, because that's what we can see multiplying around us. Imagining that any number of AI-enabled interventions can reverse this network effect is futile. We don't need AI as targeting, but as something that works to raise up whole populations. Real AI matters not because it heralds machine intelligence, but because it confronts us with the unresolved injustices of our current system. A non-fascist AI is a project based on solidarity, mutual aid, and collective care. We don't need autonomous machines, but a technics that is part of a movement for radical social autonomy.

1: The general class of algorithmic methods known as "machine learning" use statistical techniques to build a mathematical model based on training data. In this way, they can "learn" how to perform a specific task, such as classification, without needing explicit instructions. Neural networks are a specific subset that use layers of interconnected nodes ("neurons") whose output signals are computed sums of their inputs. This "connectionist" approach to machine learning has recently become massively successful and is what most people now mean when they refer to AI.

2: Backpropagation, shorthand for "the backward propagation of errors," is a mathematical method used to minimize errors in the training of a multi-layer neural network. By computing the iterative adjustments needed at each layer to improve the predictions of the network, it enables a process of "gradient descent" that optimizes the mapping between sets of inputs (data) and outputs (labeled examples). A very accessible visual explanation of backpropagation is given by Grant Sanderson of 3Blue1Brown, "What is backpropagation really doing?", 3 November 2017, https://www.youtube.com/watch?v=Ilg3gGewQ5U.

3: The classic state of exception occurs when a government declares a state of emergency during a disaster or civil unrest. Authorities gain far-reaching powers and citizens lose existing protections, for example against detention without trial. A digitally-mediated state of exception is the United States' No Fly List, which designates people who may be arbitrarily denied the right to board a plane, without explanation. Invisible algorithmic decisions to withhold resources or trigger an intervention against an individual or group have the potential to operate in a similar manner.

4: In the midst of industrial unrest in 1976, a shop steward committee at Lucas Aerospace consulted with their members about alternative products for the factory to build. Their technology designs included wind turbines, hybrid power packs, and electric cars. Despite international support, the plan was rejected by corporate management. In an Open University documentary, the workers themselves tell the story of the Lucas Plan, "The Story of the Lucas Aerospace Shop Stewards Alternative Corporate Plan," 1978, https://www.youtube.com/watch?v=0pgQqfpub-c.

5: This particular phrase appeared in a letter of 10 March 1812 from "Ned Ludd," addressed "To Mr Smith Shearing Frame Holder at Hill End Yorkshire," in *Writings of the Luddites*, ed. Kevin Binfield (Baltimore, MD: Johns Hopkins University Press, 2004), pp. 209–211. The Luddites have been consistently misrepresented in historical and contemporary accounts as being "against technology." They were actually a social movement concerned with self-regulatory power against the threats of the new capitalists and the government of the day.

6: See, for example, Donna Haraway, "Situated Knowledges: The Science Question in Feminism and the Privilege of Partial Perspective," *Feminist Studies* vol.14, no. 3 (Autumn 1988), pp. 575–599.

7: Pierre Bourdieu, *The Logic of Practice* (Redwood City, CA: Stanford University Press, 1990), p. 53.

8: Henri Bergson, *The Creative Mind: An Introduction to Metaphysics* (Mineola, NY: Dover Publications, 2010).

More-than-Human Cosmopolitics

Shela Sheikh

What forms of sociality can foster resistance to the rise of authoritarian governments across the globe? In a 2017 article, artist Jonas Staal evokes the growing, global network of far-right regimes under which we were then beginning to live: "[F]rom Trump in the United States to … ultranationalists and fascists rising throughout Europe to Erdoğan in Turkey, and from Putin in Russia to Modi in India." For Staal, "this ultranationalist and patriarchal new world order aims to impose lines of division intended to defeat emancipatory politics indefinitely." In response, Staal explores the notion of "assemblism"—or, more specifically, "a *practice* of performative assembly … that links the domains of art, theater, performance, activism, and politics"—as a means of "[building] an effective resistance mobilized by a new collectivity." Assemblism, for Staal, might provide the grounds for "a new Us with the potential to shatter the Us/Them divide that has brought the new authoritarian world order into being."[1]

Departing from Staal's conception of assemblism and reformulating these questions through "more-than-human cosmopolitics," I focus specifically on the fascist creep that is taking place, more or less conspicuously, in the context of environmental politics. In Europe, for instance, xenophobia goes hand in hand with the resurgence of eco-fascism and eco-nationalism—at its worst, a "blood and soil" version of environmentalism premised upon a reactionary form of "belonging" (a nativist sentiment that links nation and nature, local ecology and ethnicity) and the hostility directed toward human "aliens" (both citizens and non-citizens), as well as "non-native" species of plants and vegetation.[2] What is vital here are the exclusions in public (nationalist) imaginaries, state-led and nongovernmental policies, and, importantly, environmental activism. In short, whichever term we choose to use (assemblism, cosmopolitics), it is imperative to rethink who gets to be

included in the "us." In Europe alone, public protests against governments' lack of (meaningful) action in the face of climate change have escalated, as witnessed in Extinction Rebellion in the UK, for instance. But despite their numerous achievements, such gatherings—like the *gilets jaunes* movement taking place across France since 2018 and earlier public mobilizations around the 2015 COP 21 climate change conference in Paris—have received criticism for "whitewashing" the climate justice movement and silencing the voices of racialized peoples, who are disproportionately affected by climate change and environmental toxicity and cannot so easily risk police arrest.[3] What merits emphasis here is that the formation of assemblies and communities entails not only blind spots, but also exclusions in terms of who is invited to join the conversation or has their presence registered.

In reference to these environmental protests, critics have pointed to exclusions that run along lines of race and class. But exclusions also function in respect of forms of life beyond the human.[4] My interest lies in the more-than-human forms of sociality between humans and non-humans, and the political agencies that might arise through such relations. (Although, as posthumanist, postcolonial, and critical race scholars have taught us, as well as those deprived of so-called human rights, the definition of "human" is, of course, up for grabs.)[5] How might such more-than-human assemblies function as proposals for non-fascist living? I will be developing this through the notion of "cosmopolitics" set out notably by philosopher of science Isabelle Stengers. By discussing two artistic projects and their propositional aspects, a further question arises: How can artistic practices help us to imagine such forms of sociality and composition and to build a non-fascist, more-than-human cosmopolitical

world, rather than simply representing it?[6] How might artists become actively involved in cosmopolitical tensions, and how might they catalyze discussions leading to spaces not only of action but also of alternative forms of assemblism?[7]

Here, I turn to two artistic projects. The first, *Landscape as Evidence: Artist as Witness*, is a staged hearing that took place at the Constitutional Club of India, New Delhi, on 7 April 2017. The hearing involved theater director and lighting designer Zuleikha Chaudhari and Khoj International Artists' Association, New Delhi, as petitioners opposing an interstate river-linking project (involving a series of dams) that had recently been authorized under the Indian Commissions of Inquiry Act, 1952. The hearing created a forum for lawyers Anand Grover and Norma Alvares and artists Navjot Altaf, Ravi Agarwal, and Sheba Chhachhi to present their cases regarding the detriments of the project

Zuleikha Chaudhari and Khoj International Artists' Association in collaboration with Anand Grover, *Landscape as Evidence: Artist as Witness*, New Delhi, 2017, photo: Suresh Pandey for Khoj International Artists Association

to public interest. British barrister Polly Higgins's proposal to include ecocide (the wholesale destruction of the natural environment) as an international crime served as "a provocation to think about the intersection of art, law, and the environment in the context of the Indian subcontinent."[8]

Throughout the hearing, the petitioners detailed the displacement of communities (particularly indigenous) that the project would entail, as well as the damage that it would cause to livelihoods. Running throughout was a discussion of the benefits and pitfalls of development, depending on whose interpretation was taken into account and what conception of "value" was to be employed. For instance, it was lamented that studies carried out by so-called experts from academic fields were based on criteria of cost-benefit, with no accounting for the trauma that would be caused to the inhabitants of the area in question, nor that the project would cause irreversible damage to cultural heritage. Importantly for the context of the more-than-human, the testimonies also evoked the legal rights of nature, and detailed indigenous peoples' relations or cohabitation with nature and the destruction of habitat not simply for humans but also for animals (for instance, tigers), as well as the loss of thousands of species of flora and fauna. Moreover, unlike conventional legal forums, the hearing provided a platform for the contribution of artist-petitioners, who spoke of artists' capacities, through their use of different media and their experiential and impressionistic approach, to see not just the obvious but also the invisible sites of trauma and the slow, often-undetectable environmental violence. The figure of the artist was discussed not as necessarily providing straightforward solutions, but as allowing for a slowing-down of analysis in order to seek alternative strategies.

Regarding the legal rights of nature, the Indian context received global attention when, in March 2017, a court ruling granted the Ganges and Yamuna river system legal personhood after a campaign to stop its ongoing pollution.[9] The judges cited the declaration of the Whanganui River in New Zealand as a living entity with full legal rights. The argument used in India, however, was one of guardianship. As the rights of nature had been argued for in the staged hearing through human testimony, the ruling treated the river system as a minor that would be protected by local government officials in the state of Uttarakhand, which acted *in loco parentis*.[10]

The second work to which I turn takes us further in terms of conceiving of a more-than-human cosmopolitical proposal, insofar as nature is imagined not only as a rights-bearing subject, but also a potential political subject—as a "citizen" of a "cosmopoliteia."[11] *Forest Law* (2014) is a multimedia installation by architect Paulo Tavares and artist, writer, and video-essayist Ursula Biemann, based on long-term research into the Ecuadorian Amazon as a site of conflict between the Kichwa people of the Sarayaku and the oil industry.[12] The installation and the two-channel video-essay therein offer a retelling of how the Kichwa turned to courts of law—for instance the Inter-American Court of Human Rights—to make claims for the protection of the environment they inhabit. The landmark case, *Kichwa Indigenous People of Sarayaku v. Ecuador*, in which the Sarayaku sued the state of Ecuador for facilitating oil extraction on their land, coincided with significant legal reforms in Ecuador, whereby a new constitution was signed in 2008 that introduced a series of Rights of Nature contending that ecosystems—the living forest, mountains, rivers, and seas—are legal subjects.[13] As Biemann writes, "this cosmovision of interdependent cohabitation is deeply

inscribed in the indigenous ethical and legal system in which the violation of natural communities equals the violation of human rights."[14] In Tavares and Biemann's words, disputes such as this over the forestlands of Amazonia "are located within and beyond the region's immediate geography. Deeply rooted in local histories of violence and dispossession as well as within a broader terrain of struggles, these conflicts reflect a global, universalist, cosmo-politics."[15]

It is worth lingering a while on the term cosmopolitics. In the face of gathering eco-fascism and resurgent nationalism, an understandable reaction would be to turn to the promise offered by cosmopolitanism. For the Greeks (notably Diogenes of Sinope, 412/404–323 BC), the "cosmopolite" (*kosmos*/"cosmos" and *polítēs*/"citizen") signified the (human) "citizen of the world." After Kant's *Perpetual Peace: A Philosophical Sketch* of 1795, cosmo-politanism took on a more political cast than its previous ethical inflection and was associated with anti-national-ism and pretensions toward an international legal order that would guarantee universal hospitality and, with this, the rights of all men and women as citizens of the world. The cosmopolitics I am referring to is, however, distinct from this. While, for many, cosmopolitanism must be understood as an open and mobile concept, for others the concepts of hospitality and inclusion upon which cosmo-politanism is premised are insufficient.[16] With regard to the more-than-human, even when traditional frameworks of cosmopolitanism are opened up to include the envi-ronment, they tend to maintain the conventional (western, modern) binary of passive nature and dynamic culture that cosmopolitics—and indeed the two works under discussion here—attempts to unsettle.[17] Confronting both the anthropocentrism and "peacefulness" of traditional conceptions of cosmopolitanism, cosmopolitics instead

welcomes dissensus and disruption, highlighting other forms of knowledge beyond the human and, as in the two works discussed, calling for legal systems in which inalienable rights are granted not simply to humans but also to nature.

A common referent here is Stengers's notion of cosmopolitics, first developed in 1996–1997.[18] As anthropologist Marisol de la Cadena and aboriginal studies scholar Mario Blaser write, Stengers "originally proposed [the term] with the intent of opening modern politics to the possibility of divergence among collectives composed of humans and nonhumans that, following her (Greek-inspired) definition of politics, agreed to gather around a concern."[19] At issue here is how "cosmos" is understood: as philosopher Bruno Latour parses, rather than "culture, worldview, [or] any horizon wider than a nation-state," as perceived or practiced by humans, the "cosmos" of Stengers's cosmopolitics does not limit the number of entities on the negotiating table, but rather embraces everything, "including all the vast numbers of nonhuman entities making humans act."[20] For Latour, Stengers "reinvented the word [cosmopolitics] by representing it as a composite of the strongest meaning of *cosmos* and the strongest meaning of *politics*," protecting each against the premature closure of the other. Cosmos, here, takes politics beyond an exclusive human club; politics resists the tendency of cosmos to mean a finite list of entities that must be taken into account.[21]

Although the term is not used in *Landscape as Evidence: Artist as Witness*, we can catch glimpses of the cosmopolitical proposal as the various witnesses called to the stand speak of the necessity to move beyond the perspectives of mere humans and include those of "nature" (as that which has been excluded from human culture)

in deliberations of "public interest." In *Forest Law*, cosmopolitics is explicitly named as a "new constitutional space wherein both humans and nonhumans gather in a political assembly," in this case, the living forests of Amazonia.[22] In other words, this "forest court," as a cosmopolitical space that is deeply rooted in histories of colonial violence, is exemplary for "[calling] for the constitution of a universalist, multi-species politics beyond the human."[23] Here, in Amerindian thought, the space of the social, unlike in western cosmology, encompasses humans and nonhumans, peoples and nature.[24] Recalling the necessity to expand the "us" signaled above, we can turn to philosopher Déborah Danowski and anthropologist Eduardo Viveiros de Castro, who write that "what 'we' call the environment is for [Amerindians] a society of societies, an international arena, a *cosmopoliteia*"—one in which every "object" is a political subject.[25] For Tavares and Biemann, such [a] conception of the forest as a

cosmopoliteia implies that every being that inhabits the forest—trees, jaguars, peoples—are ... "citizens" within an expanded polity formed by complex material and symbolic ties between society and nature. The nature of nature is social, and hence the ways we imagine, relate to, and represent nature—whether in the forums of art or law—are fundamentally political. The forest is a polis: a political arena where both the concepts of human and rights are being defined.[26]

As part of a broader resistance to the widening embrace of fascism across governments, public institutions, and civil society, protests against climate crisis and environmental violence continue to gather strength in Europe, and significant moves have been made to include ecocide in international law. In both cases, the form of assemblism continues to evolve, for instance, with the growth of people's tribunals—notably the Monsanto Tribunal and People's Assembly that took place in The Hague in 2016.[27] What such tribunals share with the artworks discussed are the elements of the speculative and propositional. As anthropologists Chowra Makaremi and Pardis Shafafi write: "In the case of tribunals and truth commissions run by prominent international law practitioners, yet without any institutional, state-sponsored mandate or enforcement capacity, people's tribunals show how communities claim ownership of international law in situations that fall in the institutional gaps of legal mechanisms and/or into the blind spots of global power politics." What is vital is that such assemblies "*generate new narratives and forms of action*, raising questions and highlighting tensions in the articulation between national, global, and transitional levels."[28] In a similar vein, these two artworks function at the level of what I have evoked above as "the cosmopolitical proposal." Firstly, both works teach "us" (i.e., in Europe, working within the legacies of modernity's carving out of

the nature/culture divide and definitions of "the political") that forms of life beyond the human hold political standing.[29] Secondly, these works echo thinkers such as Stengers, for whom, as Biemann writes, "this cosmos, this common world, is not already existing but *in need of being fabricated.*"[30]

In the case of *Landscape as Evidence: Artist as Witness*, theatricality and staging are employed as a means through which to consider how both law and theater (or performance) produce and reproduce reality and the construction of narratives. Here the staging is "an experiment, a leap of the imagination: the dismantling of an established status quo."[31] If the staged hearing performed a forum that has yet to be realized in the national and international courts—establishing an imagined forum-to-come precisely in the absence of a suitable existing institutional framework—*Forest Law* was produced against the backdrop of a legal case (*Kichwa Indigenous People of Sarayaku v. Ecuador*) that coincided with the inclusion of the rights of nature into the 2008 Ecuadorian Constitution. This is not to say that sufficient legal, political, and ecological reforms have been realized; as Biemann writes, "Ecuador's constitution recognizes nature as a juridical subject, but de facto, nature's rights are respected and enforced only as far as they don't stand in conflict with state economic interests. As it stands, for indigenous communities, the security offered by the national legal framework remains precarious."[32] What *Forest Law* achieves, through its form, is the inhabitation of a political cosmos that, following Stengers, "can only happen through a slow epistemology of perplexity, wondering, and vulnerability." Both here and in the *Landscape as Evidence: Artist as Witness* performance, the proposition is one of decelerating and respecting those forms of life that are

not usually endowed with a political voice and that "do not function within the parameters of language, reason, and cost effective productivity."[33] As Biemann writes:

> open-plan fieldwork, travelling through the forest, engaging in conversations in semi-comprehensible translations, entering the thicket and digging in the earth to collect samples, all these are ways of slowing down the pace of knowing and instead [letting] the imponderables come forth and make themselves known to us in their multiple guise[s]. It is a practice through which to form a different commons, a different cosmos.[34]

Considering the role of artists in the context of performative practices of assemblism that contest increasingly fascistic modes of governance, Staal writes: "[E]mbedding our artistic practice within social movements, we can help formulate the new campaigns, the new symbols, and the popular poetry needed to bolster the emergence of a radical collective imaginary." "We"—and, we can add, this "we" is never to be taken for granted—"can also begin to devise new infrastructures ... needed to establish the institutions that will make a new emancipatory governance a reality."[35] Whereas for Staal and others these might take the form, for instance, of parallel parliaments, stateless embassies, and trans-democratic unions, in the above I have moved from the protests that take place on Europe's streets to reconfigured legal spaces of environmental justice in formerly-colonized states, seeking to draw inspiration from the propositional nature of artist-activist interventions. By turning to these propositional legal spaces, we move from collectivities of plaintiffs or witness figures protesting in urban public spaces ("to protest" originally implied "to make a solemn declaration") to assemblies that include more-than-human actors and that are not

premised upon the exclusionary rhetoric of "belonging" or "worth" common to (eco-)fascism and neoliberal governmentality.[36] Drawing upon and reconfiguring assemblism as "more-than-human cosmopolitics"—or, more specifically, as a "cosmopolitical proposal"—allows us to move beyond the limitations of cosmopolitanism as it is traditionally conceived and to locate propositions for non-fascist living outside of western binaries of nature/ culture, active/passive, and so forth, opening up space for the traditionally marginalized "non-experts" to make both objections and proposals.[37]

1: Jonas Staal, "Assemblism," *e-flux Journal*, no. 80 (March 2017), https://www.e-flux.com/journal/80/100465/assemblism/. Staal's text was the starting point for my contribution to the "non-human assemblies" panel of the performative conference *Propositions #2: Assemblism* (BAK, basis voor actuele kunst, Utrecht, 25 November 2017), part of *Propositions for Non-Fascist Living* (2017–ongoing), developed following a 2017 collaboration between BAK and Studio Jonas Staal's campaign *New Unions* (2016–ongoing).

2: Out of the Woods, "Lies of the land: Against and beyond Paul Kingsnorth's *völkisch* environmentalism," Libcom.org, 31 March 2017, https://libcom.org/blog/lies-land-against-beyond-paul-kingsnorth's-völkisch-environmentalism-31032017; Matthew Phelan, "The Menace of Eco-Fascism," *New York Review of Books Daily*, 22 October 2018, https://www.nybooks.com/daily/2018/10/22/the-menace-of-eco-fascism/; and Jason Wilson, "Eco-fascism is undergoing a revival in the fetid culture of the extreme right," *Guardian*, 19 March 2019, https://www.theguardian.com/world/commentisfree/2019/mar/20/eco-fascism-is-undergoing-a-revival-in-the-fetid-culture-of-the-extreme-right.

3: For a critique of London's 2015 climate march, see Alexandra Wanjuki Kelbert and Joshua Virasami, "Darkening the White Heart of the Climate Movement," *New Internationalist*, 1 December 2015, https://newint.org/blog/guests/2015/12/01/darkening-the-white-heart-of-the-climate-movement. Regarding the UK's Extinction Rebellion, see Wretched of the Earth, "An Open Letter to Extinction Rebellion," *Common Dreams*, 4 May 2019, https://www.commondreams.org/views/2019/05/04/

open-letter-extinction-rebellion; and Leah Cowan, "Are Extinction Rebellion whitewashing climate justice?," *Gal-Dem*, 18 April 2019, http://gal-dem.com/extinction-rebellion-risk-trampling-climate-justice-movement/.

4: For an examination of processes of exclusion, objectification, and silencing in terms of both race and the non-human, see Shela Sheikh, "The Future of the Witness: Nature, Race and More-than-Human Environmental Publics," *Kronos: Southern African Histories*, vol. 44, no. 1 (2018), pp. 145–162.

5: For a working definition of the "more-than-human," see Anna Tsing, "More-than-Human Sociality: A Call for Critical Description," in *Anthropology and Nature*, Kirsten Hastrup, ed. (New York and London: Routledge, 2013), pp. 27–42. Regarding race, the human, and human rights, see Alexander G. Weheliye, *Habeas Viscus: Racializing Assemblies, Biopolitics, and Black Feminist Theories of the Human* (Durham, NC: Duke University Press, 2014).

6: Here I am rephrasing some questions regarding aesthetic practice raised in Ursula Biemann, "The Cosmo-Political Forest: A Theoretical and Aesthetic Discussion of the Video Forest Law," *GeoHumanities*, vol. 1, no. 1 (2015), p. 10.

7: Here I echo questions posed in Khoj International Artists' Association, *Landscape as Evidence: Artist as Witness*, 7 April 2017, http://khojworkshop.org/wp-content/uploads/2017/03/Final-Brochure.pdf.

8: Ibid.

9: Michael Safi and agencies, "Ganges and Yamuna rivers granted same legal rights as human beings," *Guardian*, 21 March 2017, https://www.theguardian.com/world/2017/mar/21 ganges-and-yamuna-rivers-granted-same-legal-rights-as-human-beings.

10: Alex Kirby, "Rivers gain legal protection from misuse," Climate News Network, 21 March 2019, https://climatenewsnetwork.net/rivers-gain-legal-protection-from-misuse/.

11: I take the term "cosmopolitical proposal" from Isabelle Stengers, "The Cosmopolitical Proposal," in *Making Things Public: Atmospheres of Democracy*, Bruno Latour and Peter Weibel, eds. (Cambridge, MA: The MIT Press, 2005), pp. 994–1003.

12: The *Forest Law* video-installation was exhibited at BAK, basis voor actuele kunst, Utrecht, in 2015 as part of the *Human-Inhuman-Posthuman* element of the *Future Vocabularies* research. See also Ursula Biemann and Paulo Tavares, *Forest Law/Selva Jurídica: On the Cosmopolitics of Amazonia* (East Lansing: Eli and Edythe Broad Art Museum at Michigan State University, 2014).

13: Biemann and Tavares, *Forest Law*, p. 81.

14: Biemann, "The Cosmo-Political Forest," p. 5.

15: Biemann and Tavares, *Forest Law*, p. 7.

16: Maja and Reuben Fowkes, "Cosmopolitics," in *The Posthuman Glossary*, Rosi Braidotti and Maria Hlavajova, eds. (London: Bloomsbury, 2018), pp. 92–94.

17: Nigel Clark, "The Demon-Seed: Bioinvasion as the Unsettling of Environmental Cosmopolitanism," *Theory, Culture & Society*, vol. 19, nos. 1–2 (2002), pp. 101–125.

18: Isabelle Stengers, *Cosmopolitics I & II*, trans. Robert Bononno (Minneapolis: Minnesota University Press, 2010 and 2011). First published in French in seven volumes in 1996–1997, followed by a two-volume abridgement in 2003.

19: Mario Blaser and Marisol de la Cadena, "Introduction: Pluriverse: Proposals for a World of Many Worlds," in *A World of Many Worlds*, Marisol de la Cadena and Mario Blaser, eds. (Durham, NC: Duke University Press, 2018), p. 12.

20: Bruno Latour, "Whose Cosmos, Which Cosmopolitics? Comments on the Peace Terms of Ulrich Beck," *Common Knowledge*, vol. 10, no. 3 (Fall 2004), p. 454.

21: Ibid.

22: Biemann and Tavares, *Forest Law*, p. 8.

23: Paulo Tavares and Ursula Biemann, "The Forest Court," in *Elements for a World: Wood–Law, Rights, Truth, Testimony*, Ashkan Sepahvan, Nataša Petrešin-Bachelez, and Nora Razian, eds. (Beirut: Sursock Museum, 2016), p. 25.

24: Ibid.

25: Déborah Danowski and Eduardo Viveiros de Castro, *The Ends of the World*, trans. Rodrigo Nunes (Cambridge: Polity Press, 2017), p. 69. (Italics mine.) Cited from the original Portuguese in Tavares and Biemann, "The Forest Court," p. 25.

26: Tavares and Biemann, "The Forest Court," p. 25.

27: International Monsanto Tribunal, 2016–2017, http://www.monsanto-tribunal.org.

28: Chowra Makaremi and Pardis Shafafi, "Critical Masses: The ethnography of People's Tribunals" (working title), *PoLAR: Political and Legal Anthropology Review*, forthcoming (November 2019). (Italics mine.)

29: "The watchword that every novice left-wing militant learns, according to which 'everything is political,' acquires in the Amerindian case a radical literality … that not even the most enthusiastic activist in the streets of Copenhagen, Rio, or Madrid might be ready to admit." Danowski and Viveiros de Castro, *The Ends of the World*, p. 69.

30: Biemann, "The Cosmo-Political Forest," p. 10. (Italics mine.)

31: Khoj, *Landscape as Evidence: Artist as Witness.*

32: "Thus, international lawyers recommend the application of a broad right-to-life concept, known as *vida digna*, which would situate such rulings more firmly in the regimes of international human rights." Biemann, "The Cosmo-Political Forest," p. 6.

33: Ibid., p. 8.

34: Ibid.

35: Staal, "Assemblism."

36: Regarding "more-than-human" witnessing collectivities, see Sheikh, "The Future of the Witness."

37: Regarding "experts" as those with the means to object and to propose, see Stengers, "The Cosmopolitical Proposal," p. 998.

An Impromptu Glossary: Open Verification

Eyal Weizman and
Forensic Architecture
(based on the lecture "Counter
Forensics" by Eyal Weizman and
the exhibition *Forensic Justice* by
Forensic Architecture)

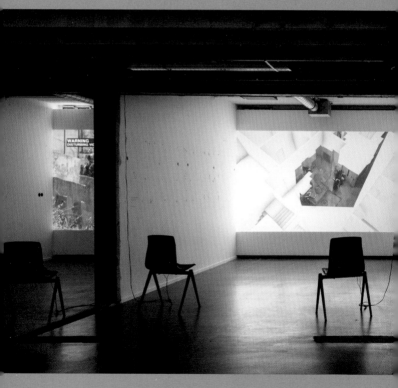

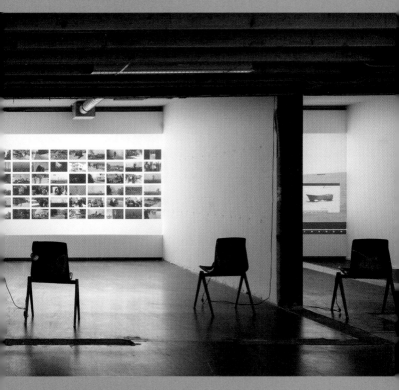

forum, *forensis*

Forensis, the origin of the term forensics, is Latin for "pertaining to the forum" as a multidimensional space of politics, law, and economy. If, historically, the term was emptied of its intricate meaning and came to refer merely to the court of law and medical science, it also lost its potential as a political practice. Forensic Architecture—architects, filmmakers, artists, coders, and journalists, who operate as a forensic agency to investigate state and corporate violence—seeks to restore the political complexity of *forensis* and perform across different forums such as the media, courts, truth commissions, and the space of culture.

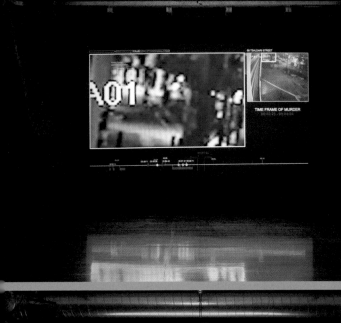

69 TSALDARI STREET

TIME FRAME OF MURDER
00:03:25 - 00:06:05

Golden Dawn motorcade

forum, *forensis*
counter forensics

Today, an evolving information and media environment enables authoritarian forces to obscure, blur, manipulate, and distort facts about their crimes. But it also offers new techniques with which civil society groups can invert the forensic gaze and monitor those forces; this is *counter forensics*.

Counter forensics is a response to changes in the texture of our present and to the nature of contemporary conflict, revolving primarily around so-called post-truth. Whatever form of reality-denial post-truth is, it is not simply about lying. Deception has always been part of the toolbox of statecraft. The defining characteristics of our era might thus not be an extraordinary dissemination of untruths, but rather ongoing attacks against the institutional authorities that buttress facts: government experts, universities, science laboratories, mainstream media, and the judiciary.

Because questioning the authority of state institutions is also what counter forensics is about—exposing police and military cover-ups, government lies, and instances in which the legal system has been aligned against state victims—it must be distinguished from the tactics of the (new) reactionary forces.

forum, *forensis*
counter forensics
resisting dark epistemology

Dark epistemology is not about facts and how best to establish them, but an attempt to cast doubt over the very possibility of there being any way to reliably establish them at all. Dark epistemology seeks to mask rather than reveal information. The strategy of dark epistemologists might seem like a new feature in the political landscape, but it is similar to that of the fascists of old, with their inclination for the "negation" of (historical) facts of past genocides and present persecutions. Authoritarian and totalitarian regimes have an inherent fear of facts because they seek to harness a disordered reality into simplified perceptual frames. But the battlefield techniques of dark epistemology and of conflict management (think, for example, of the "psyops" or "cognitive maneuvering" in military techniques to influence people's conception of reality, emotions, motives, and behavior) have also undeniably entered contemporary mainstream western politics.

In *resisting dark epistemology*, a critical approach is essential for two main things counter forensics needs to do: deconstructing false statements made by officials and reconstructing (something of) the truth of what has happened. Expose gaps, inconsistencies, biases, traces of manipulation, and misrepresentations in the statements of those in power or in places where the habit of trust might otherwise compel us to see facts. But such a critical approach must also have a constructive function. When one understands how facts are made, where their weaknesses lie, and what are the limits of what can be said, one can better construct and defend them.

153

forum, *forensis*
counter forensics
resisting dark epistemology
open verification

The attacks on traditional institutions and expertise that have so often been made in the context of the current nationalist and racist insurgency have never provided a basis for the production of counter-hegemonic knowledge. Instead of rejecting the current challenges to institutional authority and expertise, the moment of post-truth could give rise to an alternative set of truth practices that can challenge both the dark epistemology of the present as well as traditional notions of truth production.

In opposition to the single-perspectival, a priori, sometimes transcendent conception of truth embodied by the Latin word *veritas*—which connotes the authority of an expert working within a well-established discipline—a more suitable term from the same root is *verification*. Verification relates to truth not as a noun or as an essence, but as a practice; one that is contingent, open and collective, polyperspectival and multitalented, and aligned with resistance and solidarity.

The term verification could itself be associated with scientific authority. But it could also be opened up to engage with new kinds of material—open-source and activist-produced—and employ different methodological processes that open and socialize the production of evidence, integrate scientific with aesthetic sensibilities, and work across and bring together different types of seemingly incompatible institutions and forms of knowledge.

forum, *forensis*
counter forensics
resisting dark epistemology
open verification
 polyperspectivity

Open verification is collaborative and composite in nature. When an incident or accident takes place, multiple videos are often shot simultaneously by different people in different locations, each one offering a different perspective and focus. Patiently adding different local, ground-level perspectives to one another allows investigating from different points of view. The more perspectives, the more relations can be established between the actors, perpetrators, victims, and bystanders in a scene, moving transversally and laterally between different source points and world-views. It relies upon the creation of a community of practice in which the production of an investigation is socialized: a relation between people who experience violence, activists who take their side, a diffused network of open-source investigators, scientists, and other experts who explore what happened. The presentation of evidence must also be socialized with lawyers, journalists, and sometimes cultural institutions that help fund, produce, and present the work.

forum, *forensis*
counter forensics
resisting dark epistemology
open verification
polyperspectivity
unlikely common

Every polyperspectival, open verification establishes a social contract that includes all the participants in the uncanny assemblage of production and dissemination. Every case is not only evidence of what has happened, but also of the social relations that made the investigation possible. This entangled process involves calling into being an *unlikely common* between communities and institutions of different natures—scientific, political, juridical, and cultural—to create a common ground capable of qualifying evidence against false narratives and against the attack on the very capacity to collectively perceive truth.

The basic building blocks of these evidentiary methods—images, videos, material remains, sounds, and testimonies, exposing not just information but also methods of acquiring it—must form together a persuasive whole through the force of its narrative, the rhetoric of its presentation, and the momentum of its collectivity. To make a change, it needs to be mobilized as part of a social-political process, and for this, social alliances need to be built, however unlikely.

The struggle for a common ground is an essential meta-political condition: a precondition for any political practice to take place. This common might seem analogous to a natural resource such as air or a freshwater, and as such one must protect it when it is polluted by the

toxins of dark epistemologists. Yet unlike water and air, it is neither pre-existing nor natural, but a social reality that needs to be continuously remade, reinforced, and fought over. It must not be fenced off, but kept with its margins open to new information and ever-newer perspectives, evidence, interpretation, and disagreement.

forum, *forensis*
counter forensics
resisting dark epistemology
open verification
polyperspectivity
unlikely common
 evidentiary aesthetics

Rather than putting aesthetics in a separate place or even in opposition to knowledge production, there are new ways of aligning them. As the capacity to sense and detect, aesthetics has an obvious evidentiary dimension. It is also essential as the mode and means of narration, performance, and staging necessary for making evidence public and thus political. And it is evident that, when it is mainly images and videos that need to be examined, image producers—photographers and filmmakers—have a crucial role to play.

Exhibitions in art and cultural venues could act as forums complementary, and sometimes even alternative to, legal process. The practice of open verification is one of the avenues through which to re-entangle artistic and scien-tific work and bring forth a new aesthetic of facts. Rather than objectivity's "view from nowhere," open verification seeks the meshing of multiple, subjective, located, and situated perspectives. Rather than being confined to the black boxes of institutions of authority, it is based on open processes and new alignments between different sites and institutions of diverse types and standings: the science laboratory, the artist studio, the university, activist organizations, victim groups, national and international legal forums, the media, and cultural institutions.

So while there might seem to be an apparent, superficial link between post-truth and the practice of counter forensics—both approaches question statements made by government agencies like the police, intelligence services, and the courts—there is also a crucial difference. Forensic Architecture responds to the current skepticism toward expertise not with resignation or a relativism of "anything goes," but with a more vital and risky form of truth production, based on establishing an expanded assemblage of practices that incorporate aesthetic and scientific sensibilities and include both new and traditional institutions.

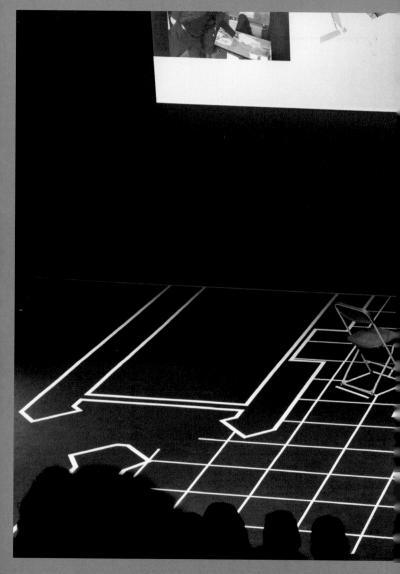

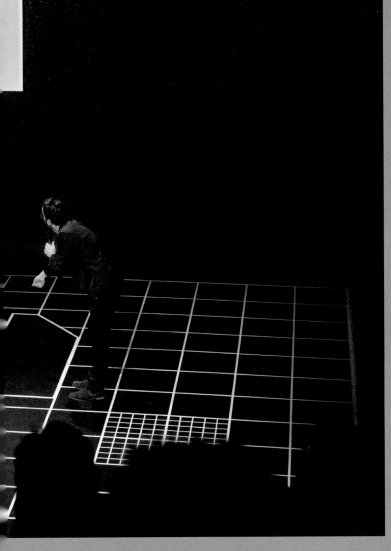

163

An Impromptu Glossary: Open Verification includes excerpts from the lecture "Counter Forensics" by Eyal Weizman, delivered on 18 October 2018 at the opening of the exhibition *Forensic Justice* at BAK, basis voor actuele kunst, Utrecht (18 October 2018–27 January 2019) and the text "Open Verification," *e-flux Architecture* in collaboration with Ellie Abrons, McLain Clutter, and Adam Fure of the Taubman College of Architecture and Urban Planning, 18 June 2019. Images are from the exhibition *Forensic Architecture*.

Images:
Forensic Justice exhibition installation view with (left to right): Forensic Architecture, *The Killing of Nadeem Nawara and Mohammed Abu Daher*, 2014, video; Forensic Architecture, *M2 Hospital Bombing*, 2017, video; Forensic Architecture, *The Bombing of Rafah, Gaza, Palestine, 1 August 2014*, 2015, video; and Forensic Oceanography and Forensic Architecture, *The Iuventa, 18 June 2017*, video, photo: Tom Janssen (pp. 142–143)

Forensic Architecture, *Investigation into the Murder of Pavlos Fyssas*, 2018, installation with video, wall print, and report, installation views, photo: Tom Janssen (pp. 145–147)

Center for Contemporary Nature, 2016–ongoing, initiated by Forensic Architecture with Fundación Internacional Baltasar Garzón, Madrid; m7red, Buenos Aires; and Haus der Kulturen der Welt, Berlin; installation view, photo: Tom Janssen (p. 149)

Forensic Architecture, *Ecocide in Indonesia*, 2016–2017, installation, various elements including video and digital prints, installation view, photo: Tom Janssen (p. 151)

Forensic Architecture, *Ecocide in Indonesia*, 2016–2017, video still (pp. 152–153)

Forensic Architecture, *77sqm_9:26min*, 2017, installation with 3-channel video, reenactment video, carpet with floor plan, and table with timeline, installation view, photo: Tom Janssen (p. 155)

Forensic Architecture, *77sqm_9:26min*, 2017, installation with 3-channel video, reenactment video, carpet with floor plan, and table with timeline, installation view, details, photo: Tom Janssen (pp. 157–159)

Eyal Weizman during his lecture "Counter Forensics," BAK, basis voor actuele kunst, Utrecht, 18 October 2018, photo: Tom Janssen (pp. 152–153)

To Live the Coming Death

Mick Wilson

Counting the Dead

The body count is a calculation of destruction. It announces itself with authority and circulates prominently in global networks of communication. The enumeration of the dead—whether of a school shooting or a suicide bombing, of a plane crash or a drone strike, of a migrant boat sinking or a war-induced famine, of a mudslide or a forest fire—indexes the catastrophic event. It provides, variously, a metric of terror, despair, depravity, or loss. It is not a sufficient or consistent metric, as the scale and relevance of violent atrocity, environmental disaster, and human loss are modulated for different media audiences with respect to racialized, gendered, and otherwise "marked" or "unmarked" bodies.

The body count is contested. When brought to acknowledge their murders, those state actors who perpetuate violent atrocities will most often invent numbers of incident fatalities lower than those given by those targeted or those who seek solidarity with the victims. A project such as the Iraq Body Count (IBC) indicates the ways in which counting the dead is understood as a politically salient act. The IBC records the violent deaths that have resulted from the 2003 military intervention in Iraq, insisting that the "record of a war's casualties must be made public." Declaring that "violent deaths are war's first and most unambiguous lethal outcome," the IBC reasons that "the systematic recording of civilian deaths is neglected, when it should be a priority."[1] The counting of the dead in state violence against racialized and occupied populations has been a fundamental engine of contemporary political mobilizations as diverse as Black Lives Matter and the global movement for Boycott, Divestment, and Sanctions against Israel.

The counting of the dead, and the contestation of the results have become an essential dimension of the depiction and the denial of genocide. This is manifest in a wide

range of atrocity calculations: from the Ottoman Empire's genocide of one-and-a-half million Armenians; the Nazi extermination of six million Jews;[2] the British Empire's famine that struck almost four million Bengalis in 1943; the Rwandan genocide of one million Tutsi in 1994; the death of two to seven million people in 1930s Ukraine under Stalin; to the contemporary destruction of a half million Western Papuans by the Indonesian state and its agents of expropriation and occupation since 1963.

This counting of the dead extends beyond the evental atrocity or the accomplished historical catastrophe. The number of the dead is projected in estimates of climate change impact, of austerity measures, of grinding poverty, of structural violence, and of myriad other gross inequities and systemic horrors that constitute the contemporary world. This grim reckoning typically makes a tally of the human dead, even where these dead have been casually exposed to death precisely because they are bodies designated, with assured conviction, as less human, subhuman, or inhuman. The enumeration of dead human beings seems everywhere the common denominator through which human violence and "natural" disasters should be accounted.

Accounts of Human and Non-Human Death

The anti-colonial revolutionary intellectual Frantz Fanon warned long ago of the empire of insouciant violence founded upon talk of the human: "Europe where they are never done talking of Man, yet murder men everywhere they find them."[3] For Fanon, when one searches for the human "in the technique and the style of European thought," one sees only a succession of negations of the human and "an avalanche of murders." The counting of the dead, as with the census of the living, is of course a

central technique within that great European project of biopolitics and the management of populations, identified in the historico-philosophical analyses of Michel Foucault. Enlightened state husbandry and care for the life of the populations have long since grown to become the earnest engines of "vital massacres" that shape the dispossessions, the famines, and the genocides that compose colonial modernity.[4]

The poet-philosopher Édouard Glissant proposes a different project of care and a different politics of thinking when he begins *Poetics of Relation* (1990) by noting that the "only written thing on slave ships was the account book listing the exchange value of slaves."[5] He disabuses his reader of the arithmetic of atrocity when he writes: "Over the course of more than two centuries, twenty, thirty million people deported. Worn down, in a debasement more eternal than apocalypse. But that is nothing yet."[6] The seemingly casual slippage, from twenty million to thirty million victims in the count of the Atlantic slave trade, operates not out of indifference to the scale of destruction and the immiseration of human life. It acts instead as an interruption to the presumptive capture of the enslaved in the flimsy digits of the accountant's grasp. Ambiguation of these fatal numbers discloses the impoverishment of an imaginary that would aggregate all this horror in one pristine integer. This imaginary belongs to those who, in their confident arithmetic, would hope to fathom the open rip in history gouged out in the waters of the Black Atlantic. Those who seize upon whole numbers in a complacent historical reckoning of these broken worlds, these continents of wreckage, these white abysses.

In her poetry cycle *Zong!* (2008), M. NourbeSe Philip closely reads the slaver's ledger that Glissant invokes. *Zong* was the name of the infamous ship from which

slaves, being transported from West Africa to Jamaica in 1781, were jettisoned and massacred so that their insurance value could be claimed. NourbeSe Philip writes about her research process:

> I receive a copy of a sales book kept by one Thomas Case, an agent in Jamaica who did business with the owners of the *Zong*. It is typical of the records kept at that time: Purchasers are identified while Africans are reduced to the stark description of "negroe man," [*sic*] "negroe woman," or, more frequently, "ditto man," "ditto woman." ... This description leaves me shaken—I want to weep.[7]

NourbeSe Philip's text registers an affective density that this banal accountancy disavows. "The African men, women, and children on board the *Zong* were stripped of all specificity, including their names. Their financial value, however, was recorded and preserved for insurance purposes, each being valued at 30 pounds sterling."[8] In the legal battle that ensued over the insurance claims, the Solicitor General of England, John Lee, argued vigorously that the killings were not a question of murder but of property and insurance.[9] This reduction of man, woman, and child to commodity is the social death that seeks to effect an ungrievable life.

In a different reading, philosopher Denise Ferreira da Silva calls attention to the material persistence of both the dead and the living slave body as matter insinuated and dispersed into the historical present. Ferreira da Silva asserts that the vital space of the Atlantic

> ...is constituted by these dead people who did not complete the voyage between the West African coast and the Americas or Europe. And not only

the dead ones: those who completed the crossing to be sold as slaves also left traces of their bodies, as sweat, blood, urine, spit in the waters along the way. Residence time (the measure of duration for the persistence of different materials in the ocean) reminds us of that. Residence time also tells us that traces of the flesh of the dead slaves remains here/now as part of the composition that is the Atlantic Ocean.[10]

For Ferreira da Silva, it is in the reduction to disaggregated matter of a dispersed "object" body that an affective agency, in excess of the banal accountancy of the ship's ledger, is registered. Across NourbeSe Philip's and Ferreira da Silva's readings there is an unfinished and rebounding movement between the human dead as the singular named or unnamed beings denied humanity and the human dead as the de-singularized material human remains that persist in the ocean and in the food chain, and so co-constitute, together with the living generation, the historical present.

Some have announced that it is only the human that dies, and that all other life merely perishes.[11] But others have revoked this closure of the community of the dead. There appears to be a new conviction among scholars that more than the human, and other than the human, dies. In this expanded and inclusive community of the dead, one learns the new and escalating accountancies of non-human death that bravely measure the extinction of species and the destruction of biodiversity. Accompanying these new measures, some construct the new crime of ecocide, to be placed alongside genocide and politicide.[12] Nevertheless, juridical longings, however, chase after the arithmetics of atrocity in the boundless confidence that the whole world is still given over to some humans for them to demarcate, enumerate, and legislate.

In this expanded accountancy of catastrophe, the projections of the body count seem to attain to a new exponential register of the biopolitical, as the population of populations becomes the object of the coming power. The imaginary of this grand accountancy allows that some humans have arrogated to themselves the right and the capacity to manage all life on the planet. In the concluding section of *History of Sexuality Volume I*, Foucault already announces the way biopolitics and its management of the population turns into a politics of death, a thanatopolitics, that liquidates the very life it claims to protect.[13] Given the grandly murderous schemes of historical biopolitics, what limitless murders could be commissioned in the name of a planetary caring for all of life, for all that lives, and for all that has yet to live?

There is here a doubling of the double bind. If the dead, all those designated for the earliest of graves are not counted, how will anyone comprehend the enormity of the crime? And if the dead are counted, how will the calculation that balances the death of a few millions here and there against the life of all living things and all that has yet to live be refused? If mass extinction, not attended to the enormity and vast scale of human-caused[14] environmental degradation, to climate change, and population destruction are not attended to, that equates to complicity in the wilful destruction of worlds. If these images of mass destruction and the threat of myriad species' death are politically mobilized, however, then, those powers are augmented (already in much-bloodied evidence) that have planned the exposure of vast populations to destruction in the name of preserving other lives—great powers that may now operate in the name of preserving the very possibility of life itself.

If one holds to talk of the value of a human life, so deeply embedded within the liberal dogma of possessive individualism, then one simply continues to work out the horrors of the ever-mobile human exclusion that Fanon so precisely named. If, one the other hand, one abandons talk of the human, one seems to move inexorably toward condoning the destruction of human populations in the name of the greater good of all that may yet live.

A grand demographic arithmetic is being rehearsed in the wings, which says, perhaps, that the lesser of some great losses must be incurred in order to save anything. It practices its lines: "perhaps the thirty million to be displaced around the Bay of Bengal must be let go to the coming flood"; "perhaps the twenty million in the European Union's sub-Saharan holding pen must be forfeit to the coming storm"; "perhaps it is now time for maturity and for difficult decisions as we cannot all hope to survive"; "perhaps the mercy will be to make the death easy and calm where possible"; "perhaps the mercy will be to not give them hope." But that is nothing yet.

Beyond the Accountant's Share

The economic and territorial rationalities of enslavement, of genocide, and of ecological wreckage that are accounted within all these ledgers of colonial modernity, that are routinized for the quarterly return, still do not in themselves give that sweet taste nor that righteous enthusiasm for others' pain. What in these numbers can explain the passioned labor of hacking through living bone; the joyful community gathered at the foot of the lynching tree; the twitching pleasures at the joystick of the drone; the delighted intimacy of torture; the exquisite attunement of inattentive care in the daily husbandry of unlivable lives; the infinite imagination teasing out the fine technicalities of terror; the precise decorum orchestrating

vast terrains of living death stretched out, out there just beyond the sacred border; and all the frenzied ecstasies of the kill? In service of what logic, to what grammar, may all the bloodlusts yearning for more be assigned, far beyond the rationale of population management or the reward of profit?

Philosopher and political theorist Achille Mbembe has introduced the concept of necropolitics, the subjugation of life to the power of death, to name a grammar of power beyond the management of the life of populations; a power first constituted in the colonial projects of the European powers and their slave plantations.[15] Necropolitics speaks to the way that sovereign power over life in the colonial scene (and in mutiplicitous zones of exception and cultures of terror beyond law, in death-worlds such as Gaza, a central exemplar for Mbembe) produces both a pervasive violent everyday of living death and an excessive violence of absolute destruction; a furious systemic overkill. These are dimensions of the exercise of the power of death over "life" that are not adequately addressed by the theme of biopolitics. He identifies this production of death within a framework of perceived perpetual threat—the need for endless war—as a key paradigm of sovereign power determined in the European colonial project. This is a mode of sovereignty that seizes upon "life" as its object through an orchestration of terror and death.

The anthropologist Michael Taussig, in his careful unpacking of the early twentieth-century British Consul Roger Casement's *Putumayo Report*,[16] has produced an analysis of a micro-culture of necropower that operates in excess of the accountant's share.[17] The Putumayo wild rubber boom of the early twentieth century is typical of the biopolitical logic of colonial expropriation, whereby

173

the life of the native population is by turns mobilized and liquidated in the service of the economy of the colony and of the shareholders in the metropolitan centers of empire. The demand for cheap labor to enable the wild rubber harvest generated a logic of violence and terror perpetrated upon the Putumayo peoples by the white colonial adventurers. As one commentator describes, "the natives are exposed to attack without protection of the law by the whites, who hunt and persecute them like animals of the jungle, recognizing as their only value the sum represented by their sale."[18] The harvesting of wild rubber required a system of terror to enforce the debt servitude that enslaved the indigenous people of the Putumayo in the absence of a viable wage labor system: "an estimate was made that every ton of rubber from the Amazon Valley cost two human lives ... the methods of the Putumayo must have quadrupled it. If the native rubber-gatherer were treated as an ordinary laborer and paid a due wage, it is safe to say that it would not pay to gather wild rubber at all, or only by increasing its price in the world's market very considerably."[19]

But, as Casement's famous report indicates, an economy of terror began to displace this economy of rubber, enforced labor, and debt servitude. Casement and— reading in his colonial tracks—Taussig itemize a hellish accountancy of misery, injury, torture, cruelty, terror, and murder perpetuated by the rubber-station men upon the native peoples, ostensibly to secure the necessary level of rubber harvests. Taussig then observes that in this system of terror the overseers and executioners "had lost all sight or sense of rubber-gathering—they were simply beasts of prey who lived upon the Indians and delighted in shedding their blood."[20] Quite clearly, the regime of violence and death operated by the rubber-station managers was eroding company profit, compromising the ledger's balance.

Taussig argues that while this terror had some claim to be "functional to the needs of the labor system," this does not explain "the most significant contradictions," especially "that the slaughter of this precious labor was on a scale vast beyond belief" and ultimately contrary to the needs of the enterprise.[21]

In Putumayo, the subjection of life to the power of death is not a matter of the sovereign right to put to death, nor of the letting die that is the thanatopolitical face of bio-power, but rather it is the emergence of a different moral economy of violence and terror.[22] This warrants Mbembe's proposition as to the inadequacy of biopolitics as analytic for the rationality of power in the death-world and the need for another term beyond biopolitics/thanatopolitics to name this grammar of power that produces a pervasive culture of terror and a condition of living death. Applied in this concrete instance, the descriptive and analytical value of necropolitics is moved from the theme of sovereignty within political ontology to the theme of the moral economy of violence within a specific historical project of slaughter.

The Moral Economy of Violence to Come

In the current historical juncture an intensified necrop-ower must be anticipated that predicates itself upon the vastness of the coming death and the risk to the life of life itself: the sixth extinction; ecological collapse; the massive displacement and destruction of populations through climate catastrophe. The coming death engenders the conditions for a necropolitical imaginary that will produce death-worlds rendered countable and thinkable by death counts, which will thereby render them all the more incomprehensible. What is being witnessed is the emergence of a global moral economy of violence

that modifies and recalibrates the racist and genocidal logics of colonial-modernity with which it is substantially continuous.

There is a generation that comes and says, "We did not author the carbon economy, we did not generate this ecological degradation; we inherited a despoiled world. And we have taken our historical responsibility to address the errors of the past, and redeem what of life on the planet there is that can be redeemed". This generational disavowal, taken together with a claim to responsible acceptance of the inherited burden, will provide the conditions of possibility for the new moral economy of violence.

The greatest challenge for this emergent ordering of legitimate violence will be the question of how to regulate the historically-demonstrated pleasures and ecstasies of violence where their playing fields are opened up. For even the stewardship of life and the management of the population of populations will have to give some account of its own operational practices. The acceptability to many of drowning migrants, keeping babies in cages, and the relentless attrition of occupied populations in the name of security and containment of threat are but today's small samplers of the kinds of horror that may yet come as the scale of imminent threat is vastly expanded. To be given the semblance of legitimacy, these violences must be devoid of pleasure. They must be borne with regret and disdain for their dismal but overwhelming necessity. The claim that one is not the author of a crime, merely the inheritor of its consequences, means that one must distance oneself from the pleasures and the ecstasies of the crime's avenging violence.

This is the challenge of the moral economy of violence

that belongs to the death to come: How does the coming power expose vast populations to an exclusion-unto-death without being seen as the orchestrator of a zone of living hell, a place of delight for predators? How does the coming power constitute itself as the reluctant architect of spaces of expedient and humane death in the name of the greater good of all that has yet to live? We may also anticipate that the well-worn habits of counting the dead will play their part in this coming pragmatics of violence. It may be precisely that as the death count rises, widespread recon-ciliation to the difficulties of responsible management of the population of populations will ease along and follow apace. No work upon the self will answer the question of how to live the coming death.

What, then, are the ways in which this coming death may be lived otherwise, may be resisted? Two propositions for living against its apocalyptic logic could be these: to collectively re-imagine death as something that cannot be reduced simply to non-existence; and to re-imagine forms of political community that bind the living and the dead within resolutely materialist terms. If the dead are counted as *beings* among the living—not as revenants or ghosts, but as beings in disjunctive co-belonging with the living—it may just be possible for the dead to *count*, and not simply be counted, against the moral economy of violence that is premised upon the coming death.

<u>1:</u> "Rationale," *Iraq Body Count*, https://www.iraqbodycount.org/about/ rationale/.

<u>2:</u> It is particularly notable how the figure "six million" has become a cypher specifically of the Jewish victims of the Nazi atrocities, while the target populations of Nazi genocide also included Roma people, the disabled, and homosexuals. See "Holocaust Facts: Where Does the Figure of 6 Million Victims Come From?," *Haaretz*, 1 May 2019, https://www.haaretz.com/jewish/ holocaust-remembrance-day/6-million-where-is-the-figure-from-1.5319546.

3: Frantz Fanon, *The Wretched of the Earth*, trans. Constance Farrington (New York: Grove Press, 1963), p. 311.

4: Michel Foucault, *The Will to Knowledge: The History of Sexuality Volume 1*, trans. Robert Hurley (London: Penguin, 1990), p. 137.

5: Édouard Glissant, *Poetics of Relation*, trans. Betsy Wing (Ann Arbor: University of Michigan Press, 2010), p. 5.

6: Ibid., p. 6.

7: M. NourbeSe Philip, *Zong!* (Middletown: Wesleyan University Press, 2011), p. 194.

8: Ibid.

9: "What is this claim that human people have been thrown overboard? This is a case of chattels or goods. Blacks are goods and property; it is madness to accuse these well-serving honourable men of murder. They acted out of necessity and in the most appropriate manner for the cause. The late Captain Collingwood acted in the interest of his ship to protect the safety of his crew. To question the judgement of an experienced well-travelled captain held in the highest regard is one of folly, especially when talking of slaves. The case is the same as if wood had been thrown overboard." See "The Case," *The Middle Passage*, http://zongmiddlepassage.weebly.com/the-case.html.

10: "Arjuna Neuman & Denise Ferreira da Silva, 'Serpent Rain.' Introduced by Margarida Mendes," *Vdrome*, 17–30 April 2018, http://www.vdrome.org/neuman-da-silva.

11: "The mortals are the human beings. They are called mortals because they can die. To die means to be capable of death as death. Only man dies." Martin Heidegger, "Building, Dwelling, Thinking," in *Poetry, Language, Thought*, trans. Albert Hofstadter (New York: Harper Collins, 1971), p. 148.

12: "Relevant International Crime History," *Ecocide Law*, https://eradicatingeco-cide.com/the-law/history/.

13: Foucault, *The Will to Knowledge*, pp. 135–139.

14: The term "human-caused" is employed here in preference to "anthropo-genic" because it is intended to signal the agency of "some" humans rather than the species impact of "all" humans. See Françoise Vergès, "Racial Capitalopocene," in *Futures of Black Radicalism*, Gaye Theresa Johnson and Alex Lubin, eds. (London: Verso, 2017).

15: Achille Mbembe, "Necropolitics," *Public Culture*, vol. 15, no. 1 (Winter 2003), pp. 11–40.

16: In July 1910, Sir Edward Grey, head of the British Foreign Service, placed Roger Casement in a commission going to investigate reports of atrocities on the Putumayo River of the upper Amazon. Casement's five Putumayo reports, prepared for Grey, are contained within the parliamentary papers *Correspondence Respecting the Treatment of British Colonial Subjects and Native Indians in the Putumayo District* (1912). A final version of the report was published by the House of Commons on 13 July 1913.

17: Michael Taussig, "Culture of Terror—Space of Death. Roger Casement's Putumayo Report and the Explanation of Torture," *Comparative Studies in Society and History*, vol. 26, no. 3 (July 1984), pp. 467–497.

18: W. E. Hardenburg, *The Putumayo: The Devil's Paradise* (London: T. Fisher Unwin, 1912), p. 23.

19: Ibid., pp. 46–47.

20: Taussig, "Culture of Terror," p. 478.

21: Ibid., p. 479.

22: The term "moral economy," first given explicit formulation by English historian E.P. Thompson, has been given a more generalized formulation by French anthropologist and sociologist Didier Fassin, who takes it to be "the production, distribution, circulation, and use of moral sentiments, emotions and values, and norms and obligations in social space." Didier Fassin, "Les économies morales revisitées," *Annales. Histoire, Sciences Sociales*, vol. 64, no. 6, (June 2009), pp. 1237–1266.

Contributors

Rosi Braidotti is Distinguished Professor and founding Director of the Centre for the Humanities at Utrecht University, Utrecht. Braidotti is renowned for her pioneering work in European women's studies, having served as founding Director of the Netherlands Research School in Women's Studies (1995), as well as setting-up the inter-university Socrates Network of Interdisciplinary Women's Studies in Europe, NOISE and the Socrates Thematic Network Project, ATHENA. Her work intersects with social and political theory, gender studies, feminist theory, and cultural studies. Her many books include: *Posthuman Knowledge* (2019); *Posthuman Glossary* (co-edited with Maria Hlavajova, 2018); *Conflicting Humanities* (co-edited with Paul Gilroy, 2016); *The Posthuman* (2013); *Nomadic Theory: The Portable Rosi Braidotti* (2011); and *Transpositions: On Nomadic Ethics* (2006). Braidotti lives and works in Utrecht.

Denise Ferreira da Silva is an artist and theorist. She is Professor and Director of the Institute for Gender, Race, Sexuality, and Social Justice at the University of British Columbia, Vancouver, and Adjunct Professor of Curatorial Practice at MADA, Monash University, Melbourne. Her work addresses the ethical and political challenges of the global present through the lens of feminist theory, postcolonial and cultural studies, and critical legal theory. Her artistic work includes collaborations such as the films *Serpent Rain* (with Arjuna Neuman, 2016) and *From Left to Night* (with Wendelien van Oldenborgh, 2014), as well as events and texts as part of her *Poethical Readings* practice (with Valentina Desideri). Publications include, as editor, *Law, Race, and the Postcolonial—A Handbook* (2015); *Postcolonial Capitalism: Histories & Cartographies of Global Capitalism* (2015); and the monograph *Toward a Global Idea of Race* (2007). Ferreira da Silva lives and works in Vancouver.

Forensic Architecture is a research agency consisting of architects, artists, filmmakers, journalists, software developers, scientists, lawyers, and an extended network of collaborators from a wide variety of fields and disciplines. Founded in 2010 by Eyal Weizman, it is committed to the development and dissemination of new evidentiary techniques and undertakes advanced architectural and media investigations on behalf of international prosecutors, human-rights and civil society groups, as well as political and environmental justice organizations. Forensic Architecture's work has been exhibited at, among others: BAK, basis voor actuele kunst, Utrecht, 2018; Institute of Contemporary Arts, London, 2018; White Box, Zeppelin University, Friedrichshafen, 2018; Onsite Gallery, OCAD University, Toronto, 2018; Documenta 14, Kassel, 2017; Museu d'Art Contemporani de Barcelona (MACBA), Barcelona, 2017; and La Biennale Architettura di Venezia, Venice, 2016. Forensic Architecture is based at Goldsmiths, University of London, London.

Stefano Harney and Fred Moten are authors of *The Undercommons: Fugitive Planning and Black Study* (2013) and the forthcoming *All Incomplete* (2019). *The Undercommons* has been translated into Spanish and German, with further translations under way in Thai, Portuguese, Italian, French, and Indonesian. Moten teaches in the Performance Studies Department at New York University. Harney is an independent scholar and holds an Honorary Professorship at the Institute of Gender, Race, Sexuality, and Social Justice at the University of British Columbia, Vancouver, and is a Theory Tutor at the Dutch Art Institute, Arnhem. Harney and Moten are Visiting Critics at the Yale School of Art, New Haven, CT. Moten is also the author of the trilogy *Black and Blur (consent not to be a single being)* (2018–2019) and a number of poetry collections including

The Service Porch (2016); *The Little Edges* (2014); and *The Feel Trio* (2014). Harney is author of *State Work: Public Administration and Mass Intellectuality* (2002). Moten lives in New York City and Harney lives in Brasilia.

Maria Hlavajova is founding General and Artistic Director of BAK, basis voor actuele kunst, Utrecht, since 2000. In 2008–2016 she was Research and Artistic Director of the collaborative project FORMER WEST, which culminated in the publication *Former West: Art and the Contemporary After 1989* (co-edited with Simon Sheikh, 2016). Hlavajova has instigated and (co-)organized numerous projects at BAK and beyond, including the series *Propositions for Non-Fascist Living* (2017–ongoing), *Future Vocabularies* (2014–2017), *New World Academy* (with artist Jonas Staal, 2013–2016), among many other international (research) projects. Her curatorial work includes *Call the Witness*, Roma Pavilion, 54th Venice Biennale, 2011; and *Citizens and Subjects*, Dutch Pavilion, 52nd Venice Biennale, Venice, 2007. In addition, Hlavajova is co-founder (with Kathrin Rhomberg) of the tranzit network. Hlavajova lives and works in Amsterdam and Utrecht.

Patricia Kaersenhout is a Netherlands-born artist, activist, and womanist, descendant from Surinamese parents. She develops an artistic journey through which she investigates her Surinamese background in relation to her upbringing in western European culture. Kaersenhout's work raises questions about the African diaspora's movements and its relations to feminism, sexuality, racism, and the history of slavery. With her projects, she empowers young women and men of color and supports undocumented refugees. She is a regular lecturer at the Decolonial Summer School, Middelburg; Black Europe Summer School,

Amsterdam; and the international BE.BOP (Black Europe Body Politics) conference. She held a fellowship at BAK, basis voor actuele kunst, Utrecht, 2018/2019, and has participated in international art platforms, including *The Planetary Garden,* Manifesta 12, Palermo, 2018 and *The Lotus in Spite of the Swamp*, Prospect.4 New Orleans, New Orleans, 2017. Her work is represented by Wilfried Lentz Rotterdam, Rotterdam. Kaersenhout lives and works in Amsterdam.

Lukáš Likavčan is a researcher and theorist. Trained as a philosopher, his interests focus on topics in the philosophy of technology and political ecology. Likavčan studied philosophy at Masaryk University, Brno, where he is currently concluding his PhD in environmental humanities. As a researcher, he has been based at Vienna University of Economics and Business, Vienna, Hong Kong Polytechnic University, Hong Kong, and Strelka Institute for Media, Architecture, and Design, Moscow. Likavčan was a 2018/2019 Fellow at BAK, basis voor actuele kunst, Utrecht. He lives in Prague, where he works as a teacher at the Center for Audiovisual Studies (FAMU) and as a member of the curatorial collective Display: Association for Research and Collective Practice. As an author he has recently published *Introduction to Comparative Planetology* (2019).

Sven Lütticken is an art historian, critic, and editor. He teaches at Vrije Universiteit Amsterdam, Amsterdam and has written extensively on the central role of historical theory in contemporary art and media. He is a regular contributor to international journals and art magazines such as *New Left Review*, *Texte zur Kunst*, *Grey Room*, *e-flux journal*, and *Afterall*. Publications include the forthcoming edited volumes *Art and Autonomy* (2019) and *Futurity Report* (with Eric de Bruyn, 2019), and the books

Cultural Revolution: Aesthetic Practice after Autonomy
(2017); *History in Motion: Time in the Age of the Moving
Image* (2013); and *Idols of the Market: Modern Iconoclasm
and the Fundamentalist Spectacle* (2009). Curated
exhibitions include: *The Strange Case of the Case,* Dutch
Art Institute, Arnhem, 2017; *The Art of Iconoclasm*, BAK,
basis voor actuele kunst, Utrecht, 2009; and *Lie, Once
More, Forms of Reenactment in Contemporary Art*, Witte
de With, Rotterdam, 2005. Lütticken lives and works in
Utrecht.

Wietske Maas is an artist and curator. Since 2018
she has been curator for Discourse and Public Program
at BAK, basis voor actuele kunst, Utrecht. In 2014–2017
she was researcher and managing editor for the col-
laborative project FORMER WEST. In 2008–2018 she
worked as curator for the European Cultural Foundation,
curating the annual ECF Princess Margriet Award for
Culture. As an artist she conducts politically motivated
participatory practices that activate the urban public
sphere as a site of transformative assembly. Maas has
developed projects in international contexts including
Kunstraum Niederösterreich, Vienna, 2017; Rongwrong,
Amsterdam, 2017; Haus der Kulturen der Welt, Berlin,
2015–2016; e-flux, New York, 2015; and Remai Modern,
Saskatoon, 2015. She has contributed to edited volumes
Botanical Drift: Protagonists of the Invasive Herbarium
(2018); *Courageous Citizens: How Culture Contributes to
Social Change* (co-edited, 2018); and *Supercommunity:
Diabolical Togetherness Beyond Contemporary* (2017).
Maas lives and works in Berlin and Utrecht.

Dan McQuillan is a researcher, computer scientist,
and activist. With a background in experimental particle
physics, he now teaches Creative & Social Computing
at Goldsmiths, University of London, London, having

previously worked as Amnesty International's director of e-communications. He is the founder of Multikulti, a community-led multilingual website for asylum seekers and refugees, and co-founder of Social Innovation Camp, which brought together ideas, people and digital tools to prototype solutions to social problems. More recently, he co-founded Science for Change Kosovo, a youth-led citizen science project based on critical pedagogy and focused on the issue of air quality. As an activist, he was heavily involved in the G8 protest in Genoa in 2001. Recent publications include *People's Councils for Ethical Machine Learning* (2018); *Data Science as Machinic Neoplatonism* (2017); *Counter Mapping the Smart City* (2017); and *Algorithmic Paranoia and the Convivial Alternative* (2016). McQuillan lives and works in London.

Jumana Manna is an artist whose films and sculptures reflect upon power through the exploration of the relation between the individual body and the national narrative, the alliances between humans and non-humans, and the tensions between preservation practices and the erasures that accompany them. Her works have been featured in platforms such as Ashkal Alwan, Beirut; Martin-Gropius-Bau, Berlin; Tabakalera, San Sebastián; International Film Festival Rotterdam, Rotterdam; Berlinale, Berlin; CPH:DOX, Copenhagen; Marrakech Biennale 6, Marrakech; and the Nordic Pavilion, 57th Venice Biennale, Venice. Solo exhibitions include: *A Small Big Thing*, Henie Onstad Kunstsenter, Oslo, 2019; *Wild Relatives*, The Douglas Hyde Gallery, Dublin, 2018; *A Magical Substance Flows Into Me*, Mercer Union, Toronto, 2017, and Chisenhale Gallery, London, 2015; and *Menace of Origins*, SculptureCenter, New York, 2014. Manna is based in Berlin.

Jota Mombaça is a non-binary bicha, born and raised in Natal in the north-east of Brazil. Mombaça

writes, performs, and investigates the relations between monstrosity and humanity, kuir studies, decolonial turns, political intersectionality, anti-colonial justice, redistribution of violence, visionary fictions, the end of the world, and tensions among ethics, aesthetics, art, and politics in the knowledge productions of the global south-of-the-south. Mombaça lives and works in Fortaleza, Lisbon, and Berlin.

Thiago de Paula Souza is a curator and educator. He is interested in how certain communities engage in the deconstruction of hegemonic readings of histories. He has collaborated with Lanchonete.org, an artist-led cultural platform focused on daily life and progressive action in contemporary cities, with São Paulo as a reference point; and co-created We Cannot Build What We Cannot First Imagine, a visionary platform that gathers works and perspectives from racialized artists and thinkers. He was Fellow at BAK, basis voor actuele kunst, Utrecht, 2018/2019; member of the curatorial team of *We Don't Need Another Hero*, 10th Berlin Biennale, Berlin, 2018; co-curator of *Living On | In Other Words on Living?*, Academy of Fine Arts Vienna, Vienna, 2016; and educator at Museu Afro Brasil, São Paulo, 2014–2016. De Paula Souza lives and works in São Paulo.

Shela Sheikh is a lecturer and researcher. She teaches in the Department of Media, Communications and Cultural Studies at Goldsmiths, University of London, London, where she convenes the MA Postcolonial Culture and Global Policy and co-chairs the Critical Ecologies research stream. Previously, she was Research Fellow and Publications Coordinator of the ERC-funded Forensic Architecture project, based in the Centre for Research Architecture, Goldsmiths. Recent research has focused on colonialism, botany, and the politics of planting. She

is co-editor, with Ros Gray, of a special issue of *Third Text* entitled "The Wretched Earth: Botanical Conflicts and Artistic Interventions" (2018); and, with Uriel Orlow, of *Theatrum Botanicum* (2018). Sheikh is currently preparing a monograph around "more-than-human" witnessing collectivities and aesthetic practices in the context of coloniality and environmental violence. Sheikh is based in London.

Eyal Weizman is Professor of Spatial and Visual Cultures and founding Director of the Centre for Research Architecture at Goldsmiths, University of London, London. He is a founding member of the architectural collectives DAAR, Beit Sahour and Forensic Architecture, London. Publications include *Forensic Architecture: Violence at the Threshold of Detectability* (2017); *The Conflict Shoreline* (with Fazal Sheikh, 2015); *The Roundabout Revolution* (2015); *Mengele's Skull: The Advent of a Forensic Aesthetics* (with Thomas Keenan, 2012); *The Least of all Possible Evils* (2011); and *Hollow Land* (2007). Weizman is on the editorial boards of *Third Text*, *Humanity*, *Cabinet,* and *Political Concepts* and on the board of directors of the Centre for Investigative Journalism, London, and the Technology Advisory Board of the International Criminal Court, The Hague. He has worked with a variety of NGOs worldwide and was a board member of B'Tselem, Jerusalem. Weizman lives and works in London.

Mick Wilson is an artist, educator, and researcher. He was Head of Valand Academy, University of Gothenburg, Gothenburg (2012–2018); Co-Editor-in-Chief of PARSE Journal (2015–2017); and Dean of the Graduate School of Creative Arts and Media, Dublin (2008–2012). He is a visiting faculty member of CCS Bard, Annandale-on-Hudson (2013–ongoing) and teaches curatorial practice at the

School of Visual Arts, New York (2014–ongoing). Wilson was a 2018/2019 Fellow at BAK, basis voor actuele kunst, Utrecht. Edited volumes include *How Institutions Think* (2017) and *The Curatorial Conundrum* (2016), both with Paul O'Neill and Lucy Steeds; *Curating Research* (2014) and *Curating and the Educational Turn* (2010), both with Paul O'Neill; and *SHARE Handbook for Artistic Research Education* (2013). The edited volumes *Public Enquiries: PARK LEK and the Scandinavian Social Turn* and *Curating After the Global* are forthcoming. Wilson lives and works in Brussels.

Acknowledgements

The editors thank all contributing artists, writers, and other practitioners involved in the realization of this publication, as well as the individuals and organizations listed below, who have contributed generously in a variety of ways to make it possible:

Pelumi Adejumo (Arnhem); Ursula Biemann (Zurich); Marina Gržinić (Ljubljana and Vienna); Victoria Hindley of MIT Press (Cambridge, MA); Lauren Hoogen Stoevenbeld (Utrecht); Radha Mahendru and Suresh Pandey of Khoj International Artists' Association (New Delhi); Samaneh Moafi, Sarah Nankivell, and Christina Varvia of Forensic Architecture (London); Patrice Naiambana (London); Paulo Tavares (São Paulo); and Rolando Vazquez (Scheveningen).

The activities of BAK, basis voor actuele kunst, Utrecht, have been made possible with financial support from the Ministry of Education, Culture, and Science, the Netherlands, and City Council, Utrecht.

Ministerie van Onderwijs, Cultuur en Wetenschap

Gemeente Utrecht

Index